IMAGES
of America

LEXINGTON

IMAGES
of America

LEXINGTON

Richard Kollen, Joo-Hee Chung, Heather-
Marie Knight, and Kendra Whiteside
for the Lexington Historical Society

ARCADIA

Indexed by city name only

Copyright © 2001 by Lexington Historical Society.
ISBN 0-7385-0949-3

First printed in 2001.

Published by Arcadia Publishing,
an imprint of Tempus Publishing, Inc.
2A Cumberland Street
Charleston, SC 29401

Printed in Great Britain.

Library of Congress Catalog Card Number: 2001092555

For all general information contact Arcadia Publishing at:
Telephone 843-853-2070
Fax 843-853-0044
E-Mail sales@arcadiapublishing.com

For customer service and orders:
Toll-Free 1-888-313-2665

Visit us on the internet at http://www.arcadiapublishing.com

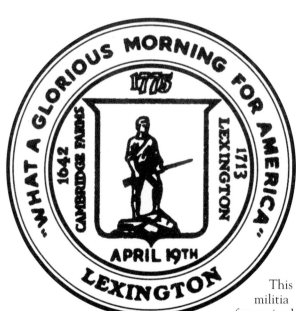

This town seal was adopted in 1934. The militia member at the center replaced the farmer in the previous seal.

CONTENTS

ACKNOWLEDGMENTS

We are indebted to the Lexington Historical Society, whose photographs provided most of the images for the book. The society's support and sponsorship of this project made it possible. In addition, its stewardship of the town's history enhanced the research for the captions. The dedicated work of the society, past and present, maintains Lexington's history as a town treasure. We also owe a great debt to past historians who have preserved Lexington's history. Many of them are listed below. Special thanks are due to Susan Rockwell for editorial assistance and to Larry Whipple, whose knowledge of Lexington's history is exhaustive. We are grateful to Wendy Parrish for the inspiration and to Guy Doran, Harold Millican, Margaret Cook, and Lois Scannell, who generously contributed their personal photographs.

BIBLIOGRAPHY

Hinkle, Alice. *Prince Estabrook Slave and Soldier*.

Howells, William Dean. *Three Villages*.

Hudson, Henry. *History of Lexington*. Vols. I and II.

Kelley, Beverly. *Lexington a Century of Photographs*.

Lexington Historical Society. *Proceedings of the Lexington Historical Society*. Vols. 1–4.

Lexington Minuteman newspapers.

Lexington directories.

Pullen, Doris L., and Donald B. Cobb. *The Celebration of April the Nineteenth from 1776 to 1960 in Lexington Massachusetts*.

Reinhardt, Elizabeth. *Suburbanization and the Rural Domestic Ideal, Lexington Massachusetts 1875–1915*. (Unpublished dissertation.)

Sileo, Tom. *Historical Guide to Open Space in Lexington*.

Worthen, Edwin B. *Calendar History of Lexington, Massachusetts: 1620–1946*.

Worthen, Edwin B. *Tracing the Past in Lexington, Massachusetts*.

The pertinent research papers for Richard Kollen's "Investigating Lexington's History" class students from the 1996–1997 to the 2000–2001 academic years.

INTRODUCTION

Lexington is justifiably proud of its historic traditions. The events of April 19, 1775, propelled the sleepy rural village into history as the "Birthplace of American Liberty." Consequently, Lexington became the namesake of 20 other towns across the country. Presidents Grant and Ford participated in the centennial and bicentennial of the Battle of Lexington. With its Revolutionary lineage as ongoing subtext, Lexington's development from farming community to suburb has continued a path linked to the historical trends in the nation.

The earliest landowners in what is today Lexington were probably speculators who resided in Cambridge and used the land for haying. By 1642, however, settlers had moved within the town borders. Historian Charles Hudson writes that the Bridges, Winships, Cutlers, Stones, Tidds, Reeds, Merriams, Wellingtons, Munroes, and Whitmores numbered among the earliest families, but at the time they lived within Cambridge's North Parish—those western woodlots and meadows called Cambridge Farms. Without a church to organize settlement patterns, most early settlers lived on the outskirts of Lexington's borders.

As a Puritan town, Lexington's church defined its existence. By 1682, the 30 families that had settled in Cambridge Farms had to travel eight miles to attend church in Cambridge. This inconvenience led inhabitants to petition the state for a separate parish in 1682. After it was granted in 1691, settlers could tax themselves to support a minister, thus avoiding paying taxes to support the Cambridge church. Nonetheless, the land remained a precinct of Cambridge. As such, its inhabitants could not provide local government or legally control schools and roads. In 1713, the Massachusetts General Court granted Cambridge Farms the right to separate from Cambridge completely as a separate township—Lexington. John Hancock, grandfather of the patriot leader, had succeeded Benjamin Estabrook at the Cambridge Farms to become the town's first minister. As with surrounding towns, slaves numbered among Lexington's population. The 1754 Massachusetts slave census reported 20 living in Lexington.

Deteriorating relations with Britain in the 1760s and 1770s politicized the towns outside Boston. During this discord, Lexington's minister and political leader, Jonas Clarke, played a pivotal role as his pulpit became a forum for political expression. On the morning of April 19, 1775, Lexington's place in history was forever etched. At dawn, a detachment of British regulars on the road to Concord to confiscate munitions stores clashed with the Lexington militia on the green, killing eight and marking the opening engagement of the Revolutionary War. Earlier, Paul Revere and William Dawes had alerted the town to the British approach. Upon arrival, Revere hastened to Jonas Clarke's residence, where John Hancock and Sam Adams were staying, to ensure these rebel leaders evacuated Lexington.

Before the Civil War, Lexington remained a farming community, but it also supported a surprising amount of manufacturing. According to George O. Smith, there existed "two saw-mills, a grist mill and a spice mill . . . and several wheelwright shops. . . . Clocks were made. . . . Here

once existed a malt-house, a pottery, a tannery and a turning mill." Most manufacturing businesses operated in East Village. Lexington also boasted 12 taverns to accommodate the stagecoaches, ox teams, and horse teams crowding the roads to Boston, laden with products from New Hampshire and Vermont farms. The coming of the railroad and, to a lesser extent, the Middlesex Canal spelled the street traffic's decline, leading to the taverns' demise.

On August 25, 1846, the Lexington and West Cambridge Railroad began its first passenger service. Benjamin Muzzey, later the railroad's president, had spearheaded a committee to gather subscriptions to fund the enterprise. Prior to rail service to Boston, Lexington's population had increased modestly, about 10 people a year from 1830 to 1840. With rail transportation to Boston, the town's population increased more rapidly. In 1870, the Boston and Lowell Railroad purchased the Lexington and Arlington Railroad franchise, by then a financial difficulty.

When the Civil War began, Lexington citizens responded. Some 244 of its sons served and 20 died in defense of the Union, some direct descendants of those who stood on the Lexington Green in 1775. At home, women's organizations supported the war effort. The First Parish Ladies Circle met in private homes for four years, sewing hospital supplies, shirts, and socks. Another organization, the Lexington Soldier's Aid Society, sent 4,096 articles to hospitals. Eight very young ladies formed USA to raise money and sew shirts for the cause. Mary Hudson writes that the girls would not divulge the acronym's title. Some called the group "Uncle Sam's Angels."

The Gilded Age industrialization and immigration that rapidly transformed cities also affected Lexington. Railroad access to Boston led to a professional class of commuters who settled near the train stations in large Victorian houses on Meriam Hill and Munroe Hill. Recent arrivals, such as Francis Hayes, Benjamin F. Brown, and George Whiting, became prominent alongside homegrown professionals, such as James Phinney Monroe. In addition, by the 1880s, foreign immigrants began to populate the town. The 1885 state census lists the proportion of residents who were first- or second-generation immigrants at 45 percent. Mostly Irish Catholic laborers and farmers, they experienced many of the same prejudices fellow countrymen faced in other Yankee communities. It was Irish families (such as Maguire, Kinneen, and Wilson, in the late 19th century) and Italians (such as Cataldo, Tropeano, and Busa, in the first half of the 20th century) that "kept farming alive in Lexington" into the 20th century, according to historian Tom Sileo. By the late 19th century, Lexington became renowned for its agriculture, especially dairy and animal breeding. According to the state census in 1875, only Worcester produced more milk and grazed more cows.

While valuing its rural character, many Lexingtonians sought urban amenities. They hoped urban comforts would attract a particular class to broaden the tax base. Despite some resistance, these reformers instituted gaslights beginning in the 1880s. The sanitary advantages of a water and sewer system led eventually to their institution. Not until the Lexington Water Company provided hydrants could fires be adequately extinguished. In 1904, a street railway was extended through Lexington into Bedford. By 1871, Lexington began reading its own weekly newspaper, the *Lexington Minuteman*. With rail access to Boston and the town's higher elevation, Lexington became a prime location for "summering" city residents. It boasted a number of hotels, such as the Russell House and the Massachusetts House. In 1884, William Dean Howells described the railroad's proximity to the Massachusetts House during his stay there: "When the trains came scuffling and wheezing up the incline from Boston, the sound was as if the friendly locomotive were mounting the back stairs."

Lexington entered the 20th century as a growing railroad suburb that retained its rural character. Farms still spanned the town. The construction of Route 128 (the Lexington section opening in 1951) became a critical watershed for the town. In 1950, Lexington's population stood at 17,335. By 1960, the town housed 27,691. In 1970, the population reached 31,886, which is near the present population. Although some of the growth can be owed to the baby boom, much was due to in-migration resulting from the town's attractiveness and easy access to Boston via Route 128. Today, as its population becomes more diverse, Lexington retains its appeal. No longer a rural village, it has grown with the nation.

One
MAKING A LIVING

In 1810, William Simonds built and kept this house as a tavern until 1828. Situated on the corner of Spring Street and Concord Avenue, Simonds Tavern stood on the Concord to Cambridge Turnpike. Eli Robbins gave dance lessons in its dance hall.

As the tavern where the several dozen militia awaited the British regulars' approach, Buckman Tavern is central to Lexington's historic traditions. Benjamin Muzzey acquired a license to keep a public house in 1693 and built the tavern c. 1709, painting it yellow and white. The dormer windows were added a century later. By 1775, John Buckman, a member of Captain Parker's company, resided as landlord. Under the ownership of Rufus Meriam, the establishment took on a higher tone, as Edward Bliss writes, holding balls and parties for "carriage folk" rather than "teamsters." After 1815, it was seldom opened as a public house. In 1913, the Lexington Historical Society leased the property for 100 years.

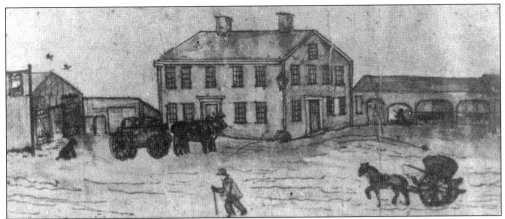

About two miles from Buckman on the old Concord Road stood Bull Tavern, a sign with a bull on display in the front. A barn for horses on one side and a shed on the other for oxen made it a very accommodating stop for travelers. Edward Bliss notes that it was raided by the British on April 19, 1775. Joseph Viles acquired the property in 1818. In 1849, all of the buildings burned.

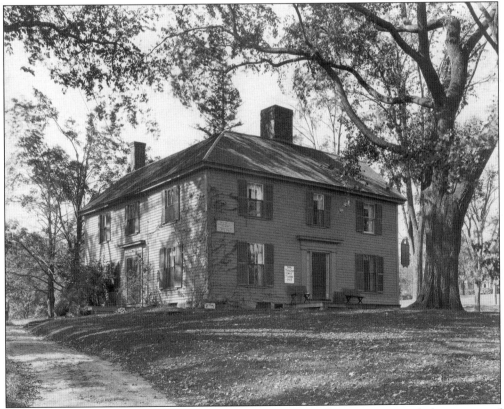

Built in the early 1690s, Munroe Tavern was named for William Munroe, orderly sergeant of Captain Parker's company. On April 19, 1775, Earl Percy's British occupied the tavern for one and one-half hours, using it as a field hospital for retreating soldiers. A bullet hole in the ceiling of the tap room indicates the conduct of some British soldiers who demanded food and drink. In 1789, Pres. George Washington dined at the tavern.

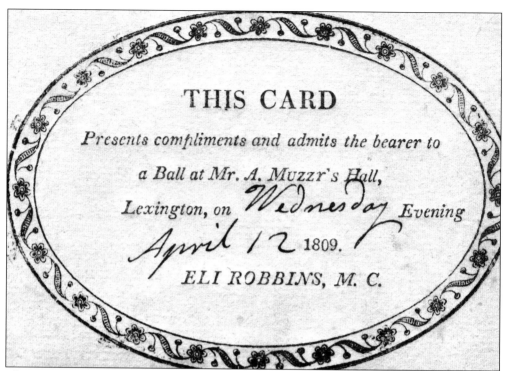

THIS CARD

Presents compliments and admits the bearer to

a Ball at Mr. A. Muzzr's Hall,

Lexington, on Wednesday *Evening*

April 12 1809.

ELI ROBBINS, M. C.

This ticket admits the bearer to a ball at the Monument House. Built by Amos Muzzey in 1802 (three years after the Revolutionary War monument was placed on the Lexington Green), the Monument House stood on Massachusetts Avenue opposite Waltham Street. This popular tavern held dinners and dances, with a fiddler providing the music. At times dancing began at 4 p.m. and continued to 4 a.m.

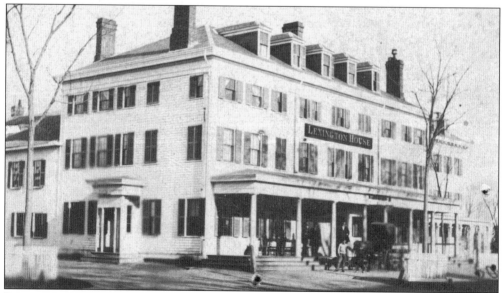

Benjamin Muzzey, to whom the tavern had passed, died in 1848. It was later called the Lexington House, and Gorham Bigelow was the most prominent of a succession of owners. In 1864, Dio Lewis purchased the building for his school only to see it burn down in 1867.

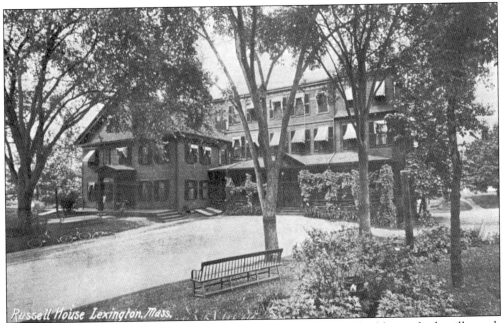

Warren E. Russell opened the Russell House in 1882. Parts of the building, which still stands on Massachusetts Avenue and Woburn Street, date to before 1775. Legend has it that on April 18, 1775, British officers demanded a meal of its occupants, the Mead family. Often called the "Doorway to Lexington," the Russell House was a favorite of Boston and Cambridge residents who wanted to summer in the country.

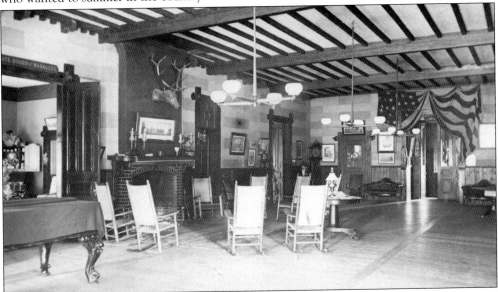

The Massachusetts House stood where the block of stores that includes Waldenbooks is located today, 1713 Massachusetts Avenue. It was built as an exhibit at the 1876 Philadelphia Exposition. After the exposition, David W. Muzzey (with financial support from Maria Cary) transported it in pieces to Lexington to serve as a hotel. Author William Dean Howells wrote about his stay there in 1882. The lobby (shown here in 1888) was its best feature, wrote Howells, and "a fire was burning all the month of May in the prodigious fireplace."

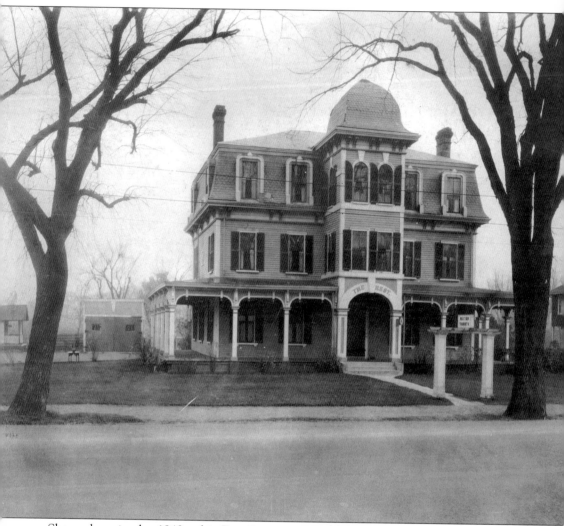

Shown here in the 1940s, this East Lexington establishment was constructed by Stephen Robbins in 1825. It failed under Robbins and his son Stephen Jr., however. Silas Cutler ran and eventually bought what became known as Cutler's Tavern. Cutler's name became so prominent that the railroad station at East Lexington was dubbed Cutler's Station. In 1837, the establishment housed church services for First Parish members reluctant to travel to the town center. The building burned down in 1875. After the fire, George Tripp of Fairhaven rebuilt it as a hotel. He installed a ballroom on the third floor, equipped with a spring floor. While in its early years, the inn enjoyed the reputation of serving a respectable patronage; this changed with a string of absentee owners and nonresident managers. Soon the Rest Inn became an establishment sought by sporting groups, seeking cockfights in the surrounding woods, card games, and alcohol. After a series of police raids, the building was torn down in 1944.

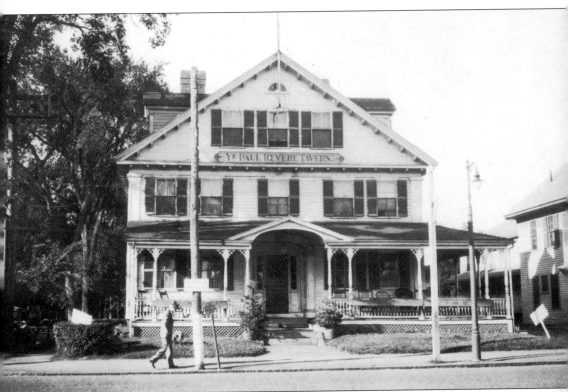

The Paul Revere Tavern, shown here, was eventually replaced by the Lexington Trust Company. Edwin Worthen indicates that the hotel was used by local people and single men. It was also a favorite of performers at Lexington Park, and the ladies of the park orchestra made it their headquarters. Previously named the Monument House (not Muzzey's, earlier tavern of the same name), Adair's Tavern, Central House, and Leslie House, it frequently changed hands. Worthen speculates that these changes may have been provoked by liquor raids.

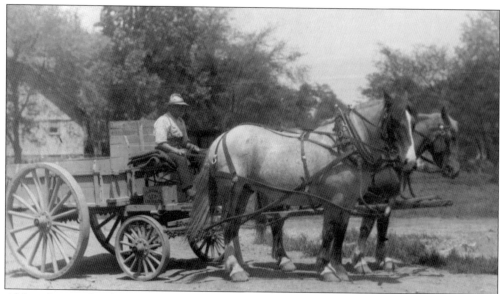

Although most farmland has disappeared from Lexington, one emblem to its agricultural past is John Douglass's farm on East Street, shown here. In the early 19th century, Lexington remained an agricultural village. A notable exception was the town's fur industry, which produced more fur than any in the Northeast aside from New York and Boston. It employed up to 500 workers. By the late 19th century, Lexington became more renowned for its agriculture, especially dairy and animal breeding. In 1875, according to the state census, only Worcester produced more milk and grazed more cows.

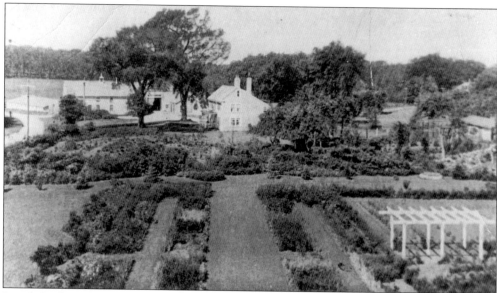

Joseph Bridge's house (built in 1722 on what was later called Grassland Farm) was located on Marrett Road near Spring Street. After changing hands a few times, it passed to Edward S. Payson in 1890. Payson used Grassland Farm to raise "blooded" horses. In the 1894 *Lexington and Bedford Directory*, he advertises Goldust-Morgan Horses and "Shetland Ponies, thoroughly broken and safe." Edwin Worthen writes that "large signs on the barn list[ed] the names of the horses."

16

Historian Tom Sileo writes that due to anti-Catholic sentiment, Hugh Maquire, born in Blacklion, Ireland, purchased his Katahdin Woods property from the Cutler family in 1864 through a proxy. As the 19th century ended, the Maquires owned the eastern length of Wood Street, approximately 200 acres. The farm transported corn, potatoes, apples, strawberries, and milk for sale in Boston or Cambridge. This photograph was taken in 1923.

The Kinneen barn and house, shown here in 1923, stood on the corner of Burlington and Hancock Streets. Irish-born Tim Kinneen purchased two acres of land in 1868. By 1888, the family owned about 200 acres spanning Grove Street to the Diamond Middle School and including today's Kinneen Park. The farm grew garden vegetables, and more than 30 cows produced milk for sale in Boston.

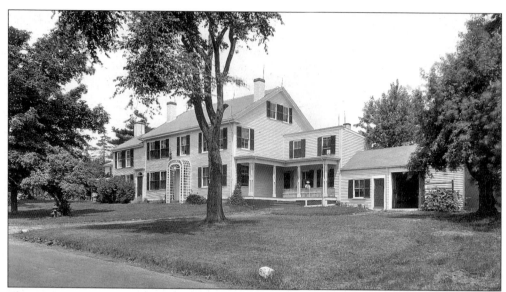

The Cutler Farm, located on Concord Avenue, is shown here in 1923. In 1714, Daniel White first sold the land to Thomas Cutler, a member of Captain Parker's company. When Nathaniel Cutler inherited and added land to the farm in 1802, it began to prosper growing herbs. Also, he and his father owned four oxen that hauled carts full of newly cut logs for sale. Nathaniel's son Thomas planted what became known as Lexington's finest orchard on the south side of Hayden Woods. The Cutlers later specialized more in dairy.

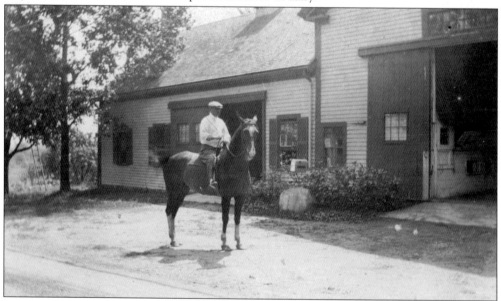

Clarence Houghton Cutler owned the Cutler Farm from c. 1899 until his death in 1933. Shown c. 1932 on his horse Scotty, Cutler had become a prominent local figure, serving on the Lexington Finance Committee and Planning Board. He was also the first master of the Lexington Grange. The Cutler Brothers, Charles and Clarence, operated a milk route to Newton, Watertown, and Mount Auburn at the beginning of the 20th century. Cutler eventually purchased his brother's and mother's land. By 1920, his assets comprised more than 150 acres, 6 horses, and 49 cows.

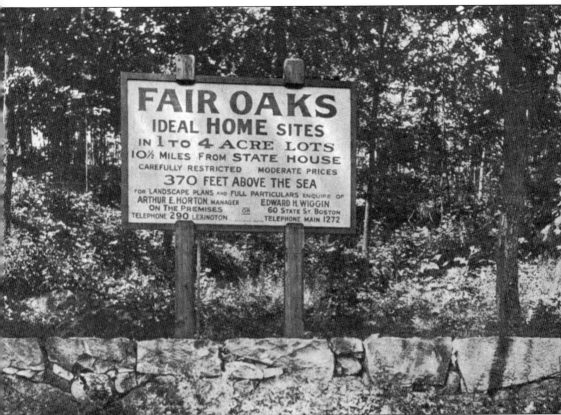

FAIR OAKS
IDEAL HOME SITES
IN 1 TO 4 ACRE LOTS
10½ MILES FROM STATE HOUSE
CAREFULLY RESTRICTED MODERATE PRICES
370 FEET ABOVE THE SEA
FOR LANDSCAPE PLANS AND FULL PARTICULARS ENQUIRE OF
ARTHUR E. HORTON, MANAGER EDWARD H. WIGGIN
ON THE PREMISES OR 60 STATE ST. BOSTON
TELEPHONE 290 LEXINGTON TELEPHONE MAIN 1272

Beginning in the late 19th century, Lexington attracted developers seeking to subdivide farmland into lots. In 1922, landscape architect Arthur Horton announced the development of the 80-acre Lawrence Estate, about a mile west of the Lexington Common. The brochure for Fair Oaks assured the buyer that deed restrictions would preserve the neighborhood's "park-like character." Clearly appealing to the commuter, it notes that a "country home affords needed rest" after a "wearisome business day in the city." The state had wanted to build an asylum for the "mentally fatigued" on this property in 1909. The outcry in the town was eventually so strong that they decided to build the "state house" (asylum) on the edge of the town.

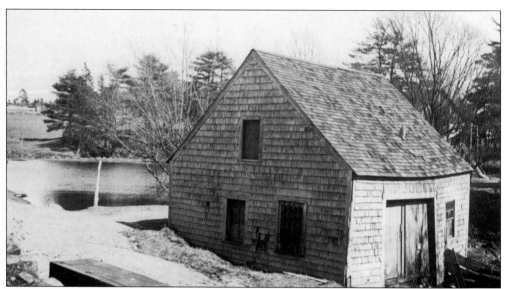

The mill and millpond of the Ebenezer Simonds estate were located on Grove Street. John Simonds first acquired this property during the late 1800s, when he moved there with his wife, Mary Tufts. Upon John Simonds's death, his son Ebenezer Simonds (born in 1795 in Medford) inhabited the property with his wife, Rachel Nichols, and later established the mill. Turning Mill Road is undoubtedly its namesake. The farmhouse stood on Grove Street at the corner of Tidd Circle but burned in the 1980s.

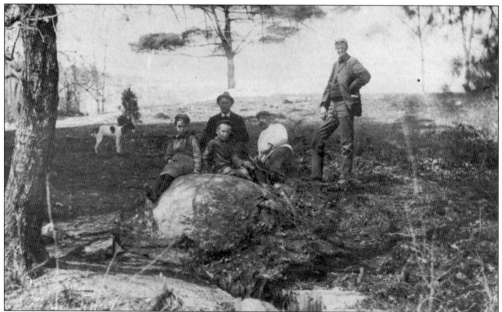

Although the paint mine area of Simonds' Woods served as a favorable destination for Sunday walks, it also provided revenue for Bowen Harrington. Harrington mined and manufactured the product found in these woods—a yellow ore that creates a reddish-brown, high-quality paint. The ore can still be detected in the hillside bank of the area. Pictured here are Franklin P. Simonds, the proprietor; Charles E. Dale, the father of Anita Dale Seymour; and Herbert Mears. The children are Kathleen and Alexander Parks. The dog's name is Jimmy.

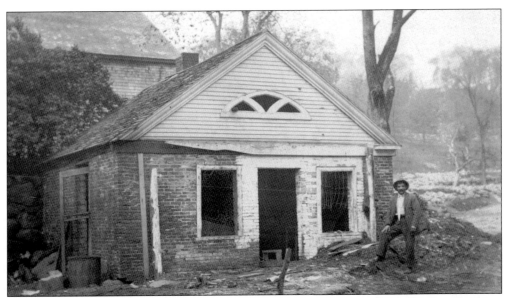

This is the cook and dye house on the Robbins property in East Lexington. Stephen Robbins, a fur dresser, purchased this land, on the corner of Massachusetts Avenue and Pleasant Street, in the early 19th century. Here, Robbins not only created his own small fortune but contributed to the overall economy of East Village. Robbins and other fur manufacturers in Lexington produced "fur capes, caps, muffs, boas, tippets, gloves, fur-lined shoes, and trimmings in variety." By the time his son Eli began to manage the business, Robbins employed between 80 and 100 men, women, and girls, creating the need for more dwellings in East Village.

These houses were located between the old Adams School and Pleasant Street. The one with pillars served as a tin shop run by a man named Merrifield. It was torn down when Follen Road was built in 1914.

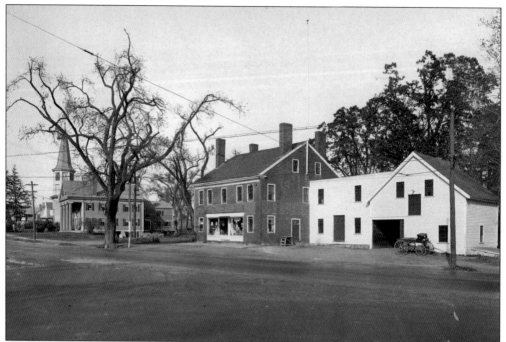

Still standing today on Massachusetts Avenue near Pleasant Street is Lexington's first brick building, the Brick Store, built by Eli Robbins in 1828. The first floor housed a post office and grocery, while the second floor functioned as a meeting room. Edwin Worthen recollects that in the late 19th century, the Brick Store was a popular gathering place to discuss local and national affairs. Alex Wilson, owner of Wilson Farm figured prominently in spirited debates. Other regular participants were Carl Mandelberg, a nearby carriage maker, and Billy Chase, an African American and "an ardent Republican" who worked for the Robbins-Stone family.

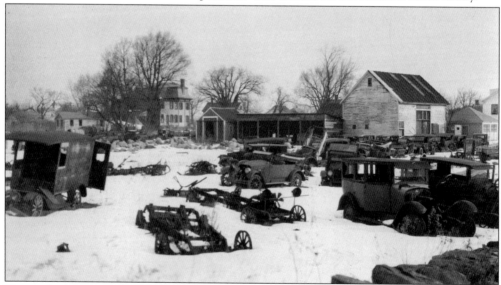

This is the backyard of Peter Canessa at 904 Massachusetts Avenue in 1933. Since that time, the area has been cleared and developed. Just beyond the buildings in the background stands the East Lexington fire station.

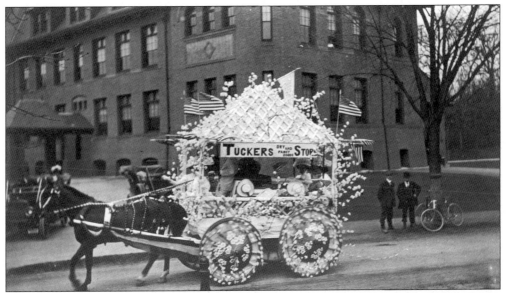

Tucker's Store entered a float in the 1910 Patriot's Day parade, earning second place in the trades exhibition category, for which owner Alexander Marcellus Tucker was awarded $10. Born in Charlestown in 1844, Tucker became a Lexington resident in 1878. With his son Arthur Forest Tucker, he ran a dry and fancy goods business out of the Hunt Building. The March 10, 1906 edition of *Lexington Minuteman* advertised lace-trimmed ladies' handkerchiefs for 12$^{1}/_{2}$¢ and malaga grapes for 25¢ a pound at Tucker's Dry and Fancy Goods Store.

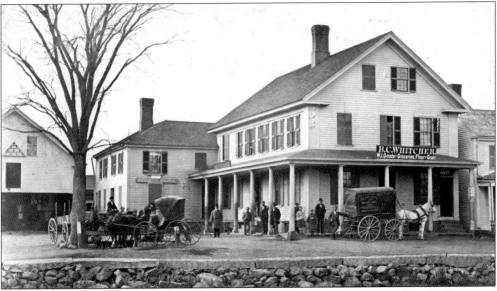

Shown here is the general store owned by Bradley C. Whitcher, formerly Saville's Store and later Spaulding's Store. An active and prominent citizen, Whitcher had served on the Lexington Executive Committee for the centennial celebration. Whitcher was also among the town members who petitioned for the Lexington Savings Bank in 1871, with the second meeting of this group being held above his store on March 28, 1871. In 1869, the Cary Memorial Library began operation out of that room. Eventually, Whitcher served as the bank's president and the treasurer. He also was elected as selectman for the town.

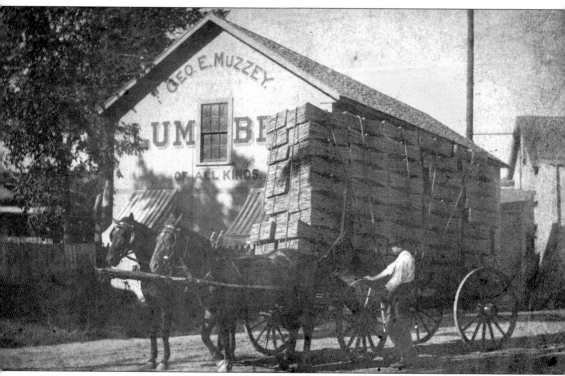

The Lexington Lumber Company—established in 1883, behind the grain business owned by George Muzzey on 1775 Massachusetts Avenue—became one of the oldest businesses in town. At that time, the business was managed by a Mr. Smith, with Charlie Onemus serving as the yard foreman. In 1912, Lexington Lumber Company moved to Bedford Street under the ownership of George Briggs and William Smith. They sold the company in 1943 to Frank Dain, Robert Brainerd, and Richard Maynard. By the 1970s, the Lexington Lumber Company had become a corporation and was run by Earl Baldwin and George Cullington. According to Baldwin, many changes had been made besides the obvious shift in delivery from horse-drawn cart to the recognizable red trucks. Although the company had maintained an enormous inventory while on Massachusetts Avenue, a stock similar to this would be prohibitively expensive today to house.

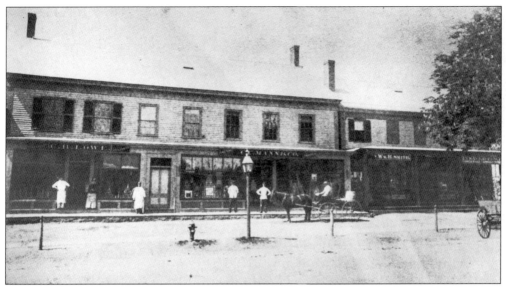

This is the Robinson Block probably *c*. 1890. Gas streetlamps were introduced to Lexington in 1877, and the Lexington Water Company installed fire hydrants in 1884.

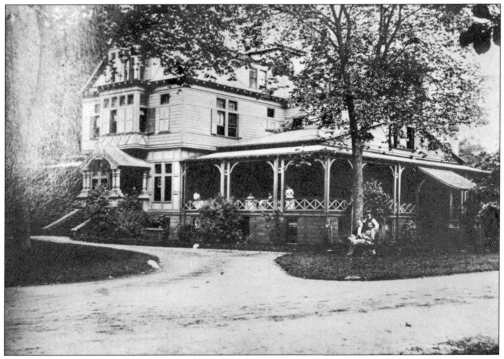

In 1892, the Massachusetts House became the Keeley Institute, a home for recovering alcoholics. Dr. Leslie Keeley had established similar institutes nationwide, 11 lasting into the 1920s. His secret ingredient was "double chloride of gold," hence called the "gold cure." The institute's advertisement claimed, "Inebriety treated as a disease and permanent cures effected." The building was torn down in 1917 after a fire.

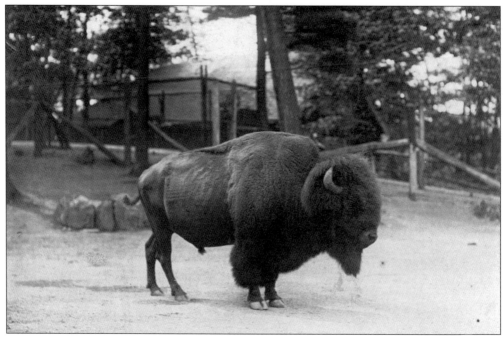

In an effort to increase its street railway business, in 1902, the Lexington and Boston Street Railway Company opened a 48-acre amusement park at the trolley's terminus on Bedford Street, opposite Westview Cemetery. Called Lexington Park, it advertised a zoo (shown here), a restaurant, an open-air dance hall, roller-skating, a rifle range, a "children's menagerie," and "no objectionable features." The 3000-seat theater promoted vaudeville, opera, and musical comedy. Cars bound for the park left Arlington Heights, Concord, and Billerica every few minutes.

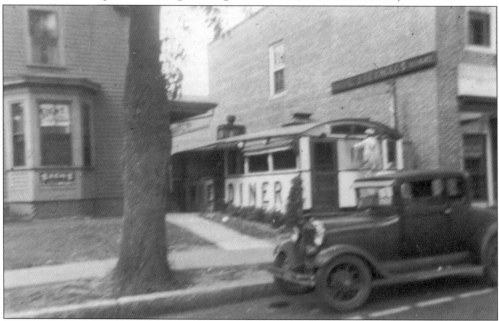

Ye Town Diner is shown in late 1939. It was located at 1732 Massachusetts Avenue and was owned by James J. Waldron. By early 1942, it relocated in Tyngsboro, Massachusetts.

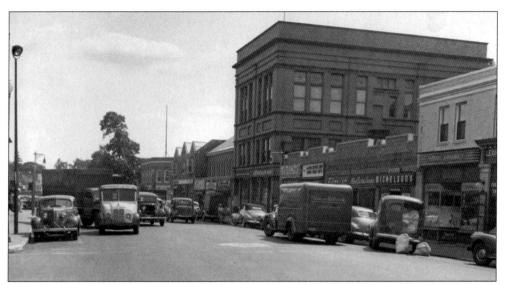

Shown here is the central business district in the 1940s. The tallest building in the photograph, Lexington Savings Bank, opened in 1871. Michelson's Shoes, which stands on the right, opened in 1919. Isadore Michelson opened it as a harness and shoe repair shop. Later, with the help of his son Harold, Michelson also began to display new shoes and a market for them was discovered. In 1965, Michelson moved his store a few doors down the street.

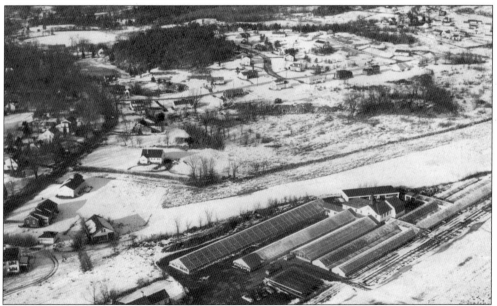

Now a division of Pepperidge Farm and the first nonfood appropriation of the Campbell Soup Company, Lexington Gardens began in 1935, when John Millican purchased some unused farmland to begin a carrot farm. Millican's only obligation for the first year was to pay taxes. Instead he managed to pay off the entire mortgage. A few years later, Millican received a request to grow plants for a neighbor to sell from a roadside stand. Carissa Carter writes that it became a huge success when the Boston Woolworth's store manager stopped at the stand by chance and ordered 20,000 dozen plants. In the 1970s, Lexington Gardens hosted the popular *Victory Gardens* on public television.

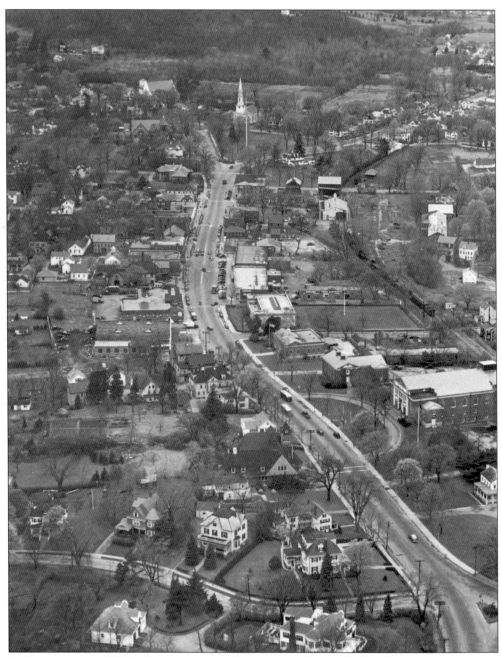

Taken in spring of 1947, this photograph shows an aerial view of Massachusetts Avenue from Woburn Street to the common. On the lower right are the school administration building and Cary Memorial Hall. A train leaves the depot farther up on the right. At the top, the First Parish steeple looms above the common.

Two
GETTING THERE

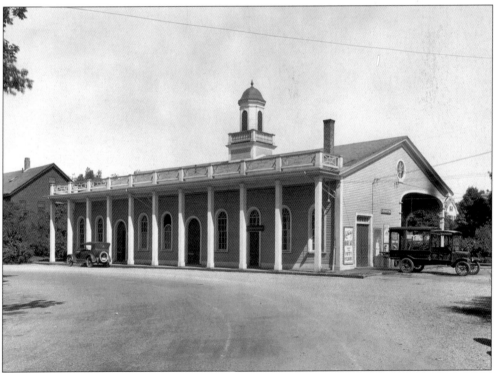

The Center Village railroad station is today the centerpiece of Emery Park. It has recently been purchased by the Lexington Historical Society to be converted into a museum. This photograph, taken in 1926, shows the depot after it had been renovated in 1918 due to a fire. Easy access to this station led to the populating of Granny Hill and Meriam Hill, with a professional class of commuters.

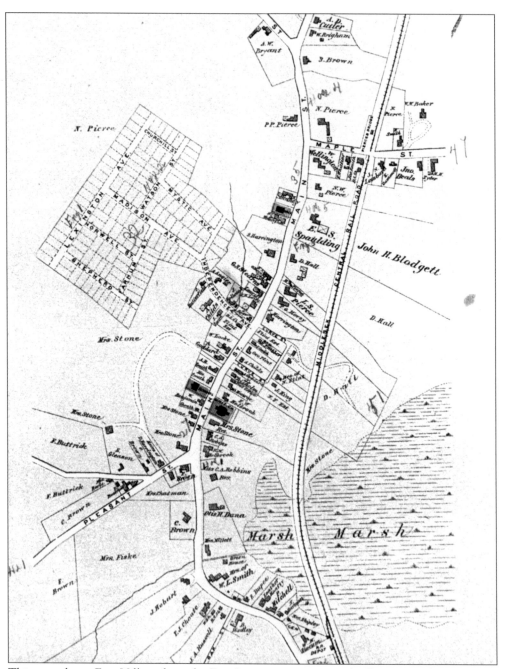

This map shows East Village from the East Lexington station to the Pierce's Bridge station. It is taken from Beers' 1875 atlas of Middlesex County. The railroad line is today a well-used bike trail.

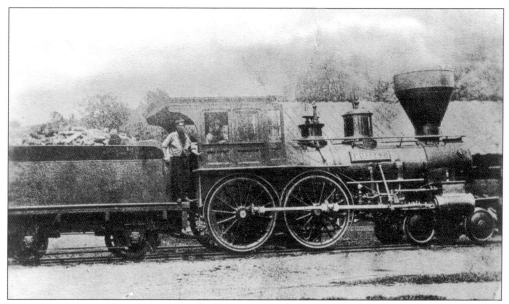

Lexington began rail service when the first train pulled into the station on August 26, 1846. Residents of Lexington and West Cambridge (today Arlington) had petitioned the legislature for an enabling act to build a railroad line. From this the Lexington and West Cambridge Railroad was born. By the late 19th century, Lexington had nearly transformed from an isolated agricultural town to a more populated suburb. While the first trains ran three times daily from Lexington to Boston, through Arlington, Cambridge and Somerville, by 1871 service increased to eight times each day and twice on Sundays.

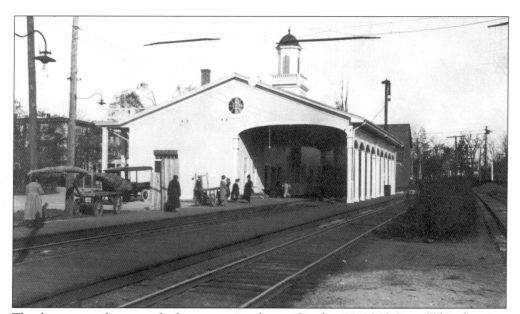

The depot opened to great fanfare on a rainy day on October 14, 1846. Larry Whipple writes that prior to the construction of the new town hall, the depot housed meetings and other public events. Today, the depot is the last remaining depot train shed in Massachusetts.

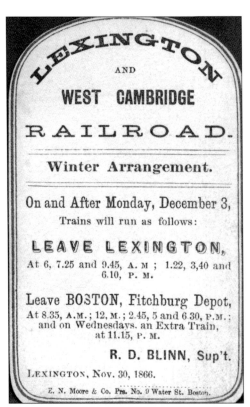

The Lexington and West Cambridge Railroad winter schedule for 1866 is listed here. A year earlier, stock and bondholders were informed that much of the stock they held was worthless. The Civil War took its toll on profits. In 1870, due to financial difficulties, the railroad was bought out by the Boston and Lowell Railroad for $140,000.

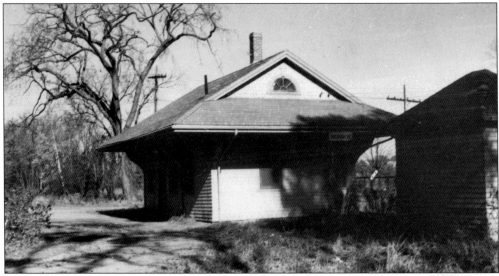

To accommodate the growth of railway transportation, service was extended to Concord and Lowell in the 1870s. By 1904, four additional stations had been constructed, including North Lexington Station at Bedford Street, the East Lexington Station, the station at Pierce's Bridge on Maple Street and Munroe Station in Tower Park, shown here in 1961. The railroad era, however, began its decline in the 1920s and 1930s, as commuters transitioned to automobiles and later discovered the convenience of Route 128. By 1945, only five trains ran on weekdays and none operated on Sundays. The company ultimately went bankrupt.

In this photograph, Middle Street, now Marrett Road, is being rebuilt as the first state road constructed in the Commonwealth. These men appear around Forbes Road, facing west. This construction began in 1898, the funds being provided by the state and the labor done by local workers. Pictured are Bill Ham (left) and John Brown (behind the boiler).

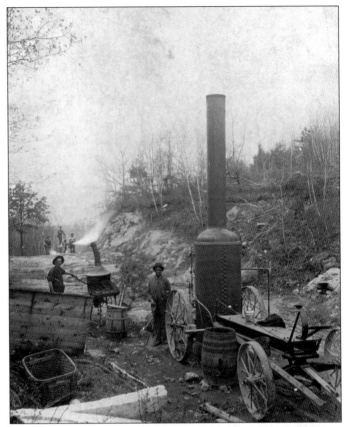

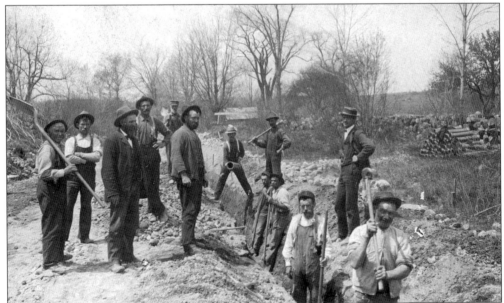

Several men work on the state road, now known as Marrett Road, in the vicinity of Route 128. Shown are Dan Harrington (with the shovel), Jim Keefe (with his arms folded), and ? Glass and James Tate (standing beside each other in the ditch).

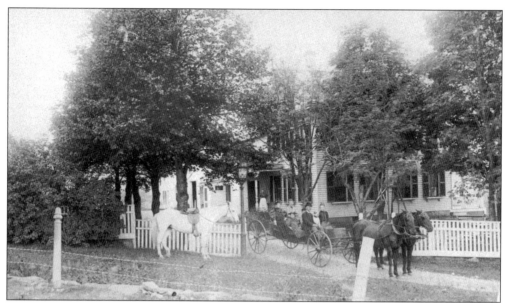

The Nichols family waits in a horse and carriage in front of the family's farmhouse, located on Oak Street. Mr. and Mrs. Edward Nichols sit in the front seat, accompanied by their children Marguerite and Ernest in the middle seat, with Emma and Howard in the rear. Edward Nichols was very active in the town and in Hancock Church. He served as Lexington Historical Society president from 1898 to 1899 and as a school committee member in 1905.

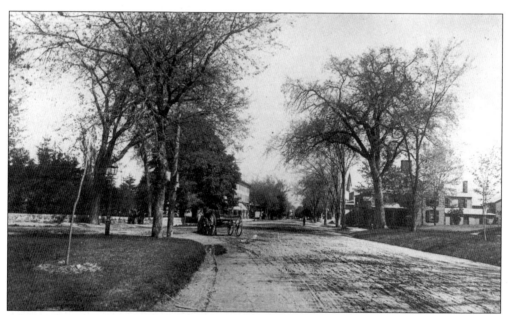

A horse-drawn cart crosses the space occupied by the Minuteman statue today. Probably taken in the 1880s, this picture shows the stone wall setting off the Buckman Tavern property from the street. Unpaved roads required care. On May 10, 1895, the *Lexington Minuteman* reported, "The watering carts were started on their rounds last Wednesday. There never has been greater need and their advent was hailed with pleasure by those who have been obliged to encounter the clouds of dust that whirl about."

Horse-drawn carriages proved more of a hazard than one might expect. The April 28, 1899 *Lexington Minuteman* reported milk, coal, and Taylor's delivery teams in three separate incidents in which frightened commercial horse teams "careened up the avenue." In one of these, a man was thrown from the carriage and received "a bad cut on the forehead." In this photograph entitled "Wilson and Steer," another beast of burden is used.

An unpaved Massachusetts Avenue crosses in front of George O. Smith's house. At the time, the house stood just below Brown's Brook in East Village at the bend in the road. During the first half of the 19th century, Massachusetts Avenue was called Hell Street by many Center Villagers because it led to East Village. The distance (and tensions) between the two villages seemed greater before the automobile.

Horse racing became popular in Lexington at the end of the 19th century. Racetracks existed in several locations in the town, including Reservoir Park. On a cold April 18, 1892 morning, an unidentified dog seems to have caught the urge. The horse seems unaffected.

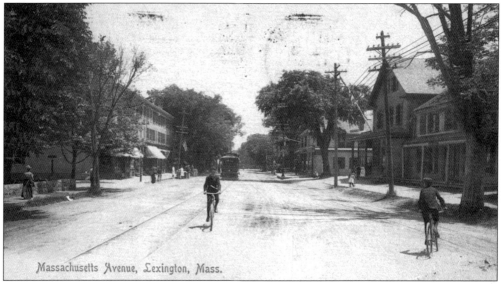

Massachusetts Avenue, Lexington, Mass.

In Lexington Center, a streetcar approaches in the distance. In the 1890s, an electric line was installed from Cambridge to Arlington Heights, replacing 30 years of horsecars, but opposition among many residents delayed its extension into Lexington until town meeting finally approved it in 1897. In 1899, the Lexington and Boston Street Railroad Company finished laying the tracks. Streetcars could present a hazard to pedestrians. The March 10, 1906 *Lexington Minuteman* reported that a little girl "was knocked down by an electric car about half past three . . . in front of the Brick Store" in East Lexington.

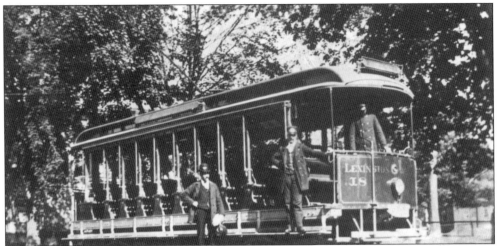

Once the streetcar line had been constructed, its popularity increased, with cars running to Waltham every half hour, Woburn every hour, and Arlington Heights every 15 minutes, during the day and in the evening. In 1902, the town benefited when the company widened Massachusetts Avenue from Oak Street to Arlington, at its own expense. At this time, residents rode streetcars from Boston and several surrounding towns to spend time at Lexington Park, a popular destination constructed in 1901 on Boardman's Grove and maintained by the streetcar company.

Seen here are several streetcar conductors. William A. Spidle is the last man on the right.

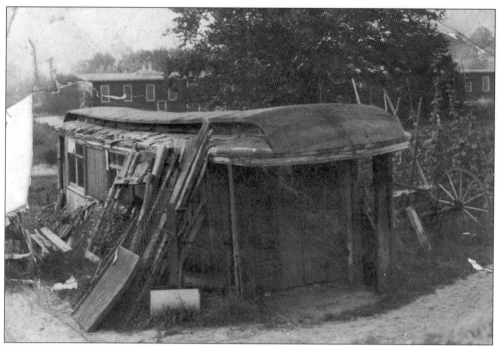

This is the backyard of William Spidle, a streetcar conductor and, later, a bus driver. By the end of 1925, buses had replaced streetcars in Lexington. Once the street trolley line was removed from Lexington, he converted an old car into a tool shed, seen here.

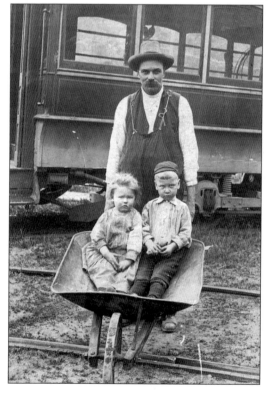

In this photograph, William A. Spidle stands in front of a streetcar with his children Lillian M. and Charles R. Spidle. William A. Spidle lived next to the streetcar barn off Bedford Street in North Lexington. Today, part of the building is Heritage Hall in the Lantern Lounge.

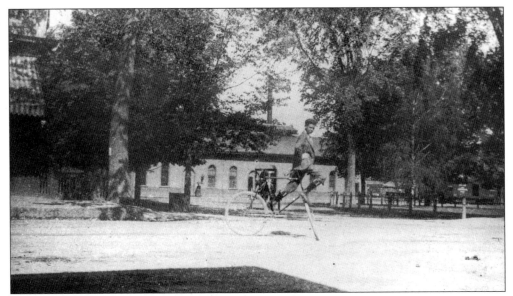

J. Chester Hutchinson rides his bicycle. In the late 19th century, bicycles took America by storm due to safety improvements from European manufacturers. The wheel size became standardized and the seat lowered. By 1899, the one million bicycles produced each year in the United States resulted in a $31 million industry. By 1909, however, the industry was nearly nonexistent due to the growing popularity of motorcycles and automobiles.

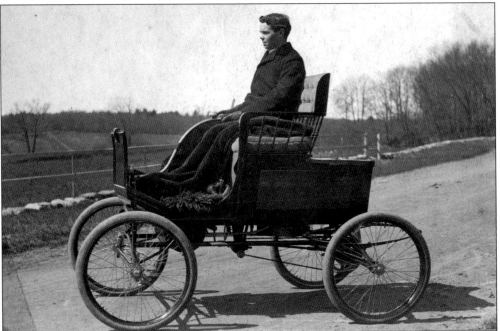

J. Chester's father, John F. Hutchinson, purchased this Stanley Steamer, a one-passenger automobile, in 1900. It was the first automobile in Lexington. Here, J. Chester Hutchinson tries it out. By 1902, he would have to obey the first state laws regulating automobile use. A Mr. Walker of Hill Street also drove the Stanley Steamer, reporting difficulty in starting it on cold winter mornings. The first woman to possess a license in Lexington was Lillian Clapp Holt.

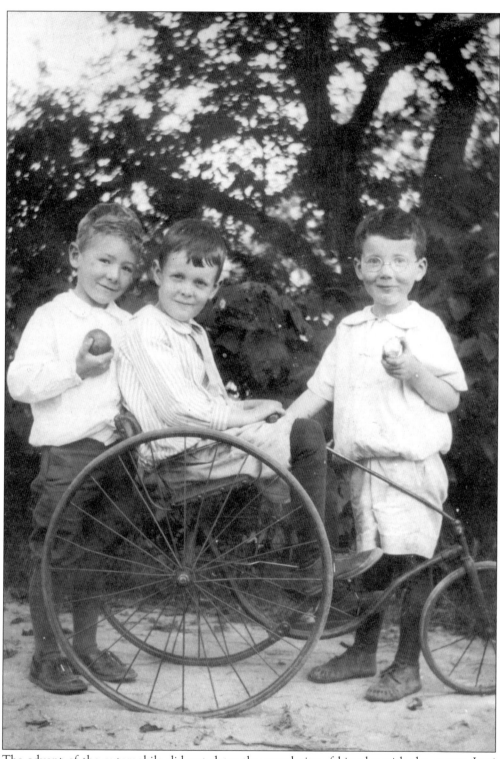

The advent of the automobile did not deter the popularity of bicycles with the young. Levi Doran's grandchildren rest from riding an older version of a tricycle.

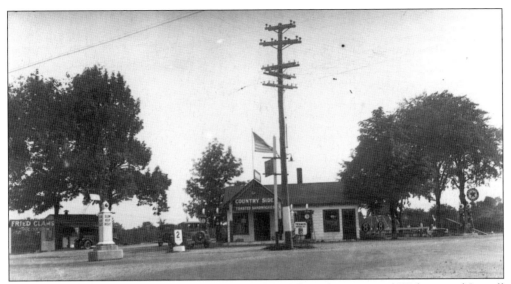

This is the original Countryside filling station, located on the corner of Woburn and Lowell Streets. Owned and operated by Irving Currier in the 1920s, this station was the first commercial building at this site. In 1938, Currier also opened the Countryside Restaurant, not shown in this picture. To the left of the station is the fried clam stand, in front of which stands the dummy police, located for years at this intersection. As recounted by Elizabeth C. Barclay, the dummy police would never remain in the same location during the course of a Saturday night due to drivers who could not maneuver around it, despite the blinking yellow light on the top.

By the end of World War I, the majority of the population drove gasoline-powered automobiles, replacing those run by battery that had a maximum speed of only five miles per hour. Thus, service stations became necessary to support this transition. In 1921, Child's Filling Station, seen here, was built at 409 Massachusetts Avenue. Viano's Garage preceded this station a year earlier, and Minute-Man Garage, at 39 Bedford Street, opened a year later. By 1965, 11 service stations existed in the town.

In this view looking toward Lexington Center in 1929, cars travel in both directions on Waltham Street, between Winthrop Road and Park Drive. In that year, the state began to institute some traffic regulations. The annual report for 1929 reveals 319 traffic accidents, two fatal, in Lexington.

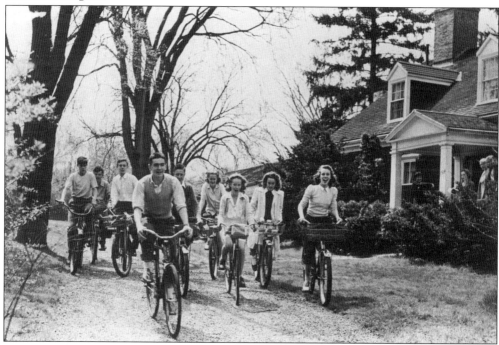

This photograph was taken in 1942 or 1943 in front of the Sanderson House at 1314 Massachusetts Avenue. In 1942, due to the war, the Columbia Manufacturing Company of Westfield, Massachusetts, was the only manufacturer with legal permission to produce bicycles and was limited in its output. For this reason, the consumer needed special stamps to purchase bicycles. The company's most popular model throughout World War II was the Victory Bicycle.

Three
SCHOOL DAYS

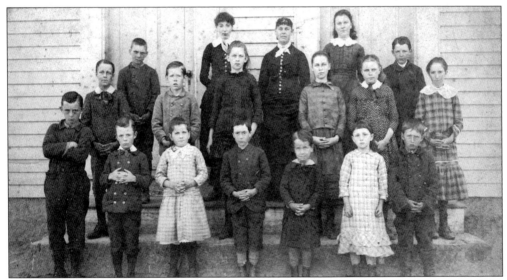

The Bowditch School, later the Tidd School, located on North Hancock Street, served the North District. Today, it is the office of Larchmont Engineering. In this 1881 class photograph, the age range reveals that the school was ungraded. Emma Wright (back row, center) had been teaching since 1875. Tidd was one of six ungraded schools along with Franklin, Howard, Adams, Hancock, and Warren. In an effort to centralize the school system, students from these district schools transferred to the new Hancock School in 1891.

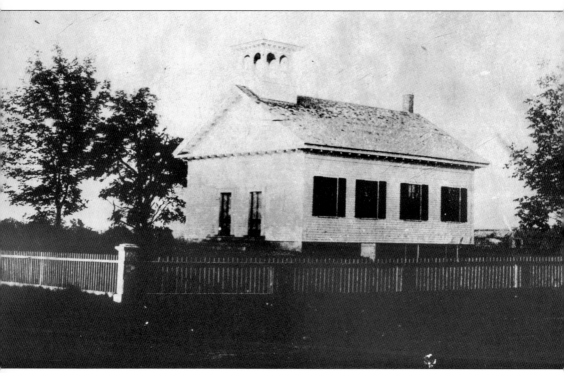

Before Lexington voted to erect three schoolhouses in 1795, only one "grammar school" in the town center existed. All other schools were privately run by female teachers. By 1804, three new schoolhouses were constructed and located in the Scotland district, Smith's End, and the center of town. Later, the number of district schools grew to the six previously mentioned. By 1882, however, the Scotland's school population (also known as Howard School) had decreased to 16 and the school committee report included discussions about closing it down. The school had served the Lowell Street community but, by 1889, more than half of the 21 pupils lived too far from school to go home for lunch. The school committee had assigned to the Scotland School students from other districts in an effort to increase the school population. Moreover, the system of ungraded district schools was perceived as outdated. When the new Hancock School was established to centralize the school population, the Scotland School closed.

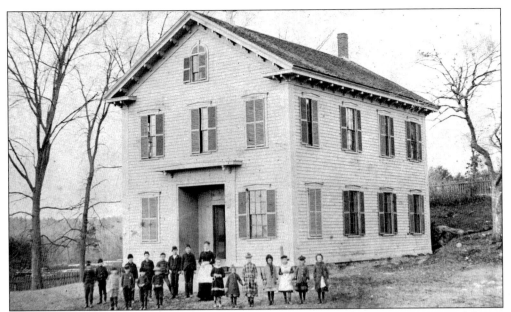

The Franklin School, located in the Kite End district on Concord Avenue, was one of the six district schools in Lexington. In 1882, when this photograph was taken, the school committee reported that the students at Franklin did "satisfactory work." The school's teacher was Maria A. Butterfield, who later went on to teach at the Scotland School. The Franklin School was closed in 1890 with the centralization of Lexington's public school system.

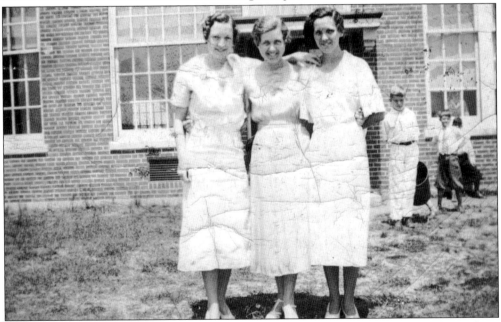

In front of the new Franklin School on June 20, 1933, stand three of the school's eight teachers. The school was constructed in 1931 to accommodate a rising population, and the school's organization was graded. When this photograph was taken, Mary Kelley taught third grade, Bertha Vik taught first grade, and Mildred Ferguson taught fifth grade. The Franklin School had enrolled 244 students when the school year opened in 1933.

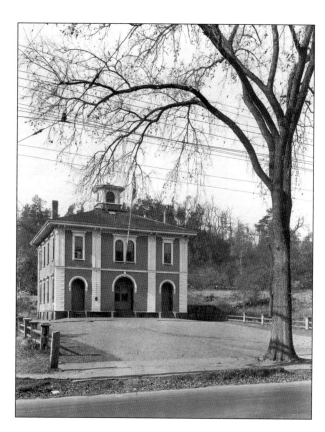

The old Adams School, across the street from Follen Church, was a two-story structure built in 1858 for $4,000. Carrie Blake instructed the older students, and Edwin Worthen remembers her fondly for joining the boys at Great Meadow to shoot black water snakes. By the early 1900s, the old Adams School was considered "unfit" for modern educational practices. To update it, the school committee tried various solutions, such as rearranging rooms, modernizing sanitation, and extending the recreation area by adding a piece of land (a gift of Ellen A. Stone) at the back of the school.

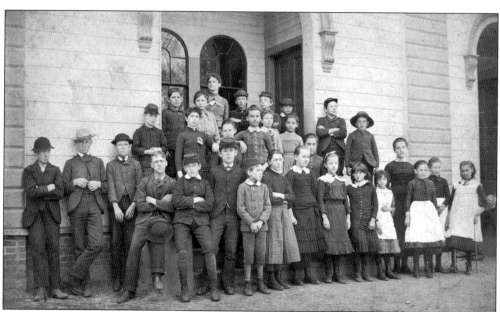

Students at the Adams School pose for a class picture in 1885. Due to rapid population growth along the Arlington border, the East Village school population increased rapidly, leading to crowded classrooms.

On May 16, 1890, the *Boston Evening Record* included a story about the presentation of a piano to Carrie Fiske. It proved to be a townwide event. Carrie Fiske taught primary grades at the Adams School from 1872 to 1917. In the 45 years of continuous service, she became a beloved member of the community.

The Color Guard was an organization comprised of boys from each of the elementary schools in town. This view shows one from the Adams School in 1900. Boys who were members of the Color Guard marched in various town parades until the 1930s.

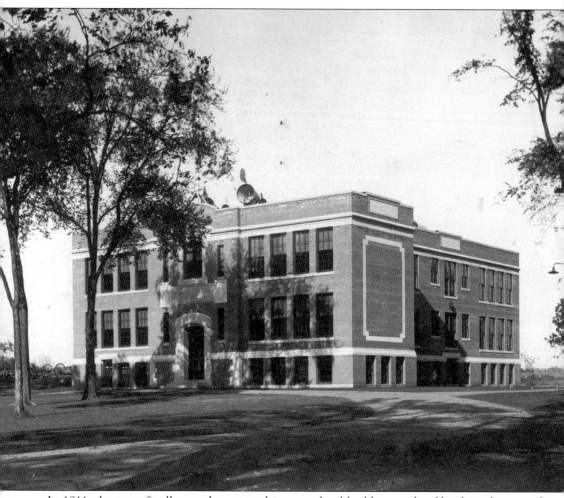

In 1911, the town finally voted to erect this new school building made of brick in the rear of the Stone Building. At a cost of $55,000, the new Adams School opened in 1912. This newest Adams School eventually closed its doors in 1981 due to declining school population but, while in session, it provided a nurturing educational environment. Douglas Clark, a sixth-grade student at the Adams School in 1961, recalls that he enjoyed being near the East Branch Library. He frequented Wardrobe's Pharmacy on Massachusetts Avenue, a drugstore with a lunch counter—his favorite after-school hangout because it had very good root beer. Clark considers his Adams School experience a very positive one, especially because of a memorable teacher, John Russell. Clark remembers this teacher was "slightly baffled by set theory, new highbrow mathematics after Sputnik and puzzled over the null set," but, nevertheless "he was a great teacher."

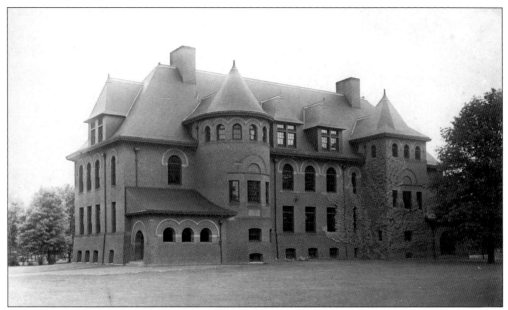

The school committee merged the six ungraded district schools into the Adams School and the new Hancock School in 1891 (shown here) after the old one was destroyed by fire in 1890. With this innovation, students could learn with peers of similar ages, and teachers could specialize in subject matter. School superintendent J.N. Ham reported this to be the most important step taken since the town's institution of a high school.

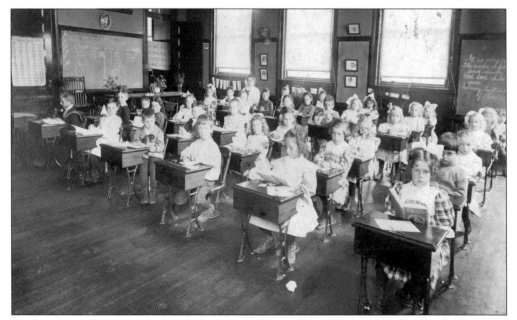

Students attend Miss Rogers's 1905 first-grade class at the new Hancock School. The *Lexington Minuteman* writes that on the first day of opening, "the children were almost wild with pleasure and excitement" and that they "appreciated the beauty and convenience of the new school, there could be no doubt." On 2.9 acres of land the new Hancock School contained eight classrooms and could house as many as 216 pupils. Today, the building houses condominiums.

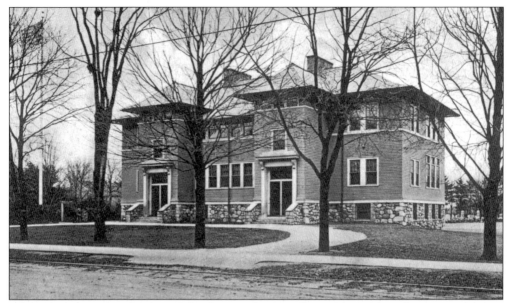

When the Hancock and Adams Schools proved too small to accommodate the growing student population, the ninth graders were moved to the Lexington High School. This did not suffice, however, and, in 1904, the town voted to erect an additional schoolhouse for children up to the ninth grade. It was designed by Lexington architect Willard D. Brown at the cost of $28,000. The school opened the following year and was named the Munroe School.

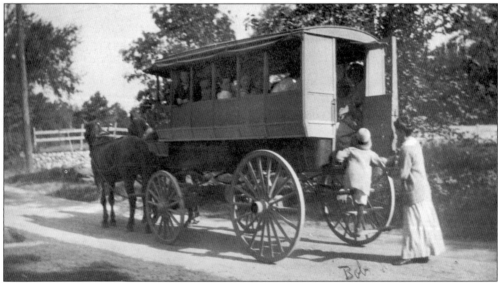

With the centralization of the grammar schools into Hancock, Adams, and Monroe, students now had to be transported out of their neighborhoods. The same year Hancock opened, the school barge was instituted. Shown here is Bob Doran being helped into the vehicle by his mother. The transportation costs to the town, however, proved greater than predicted in the school committee report. For students waiting for a barge in the outlying areas, it was a hardship. Nonetheless, the authors who updated Charles Hudson's *History of Lexington* in 1913 noted that the advantages outweighed the disadvantages and predicted the town was "not likely to return to a system of district schools."

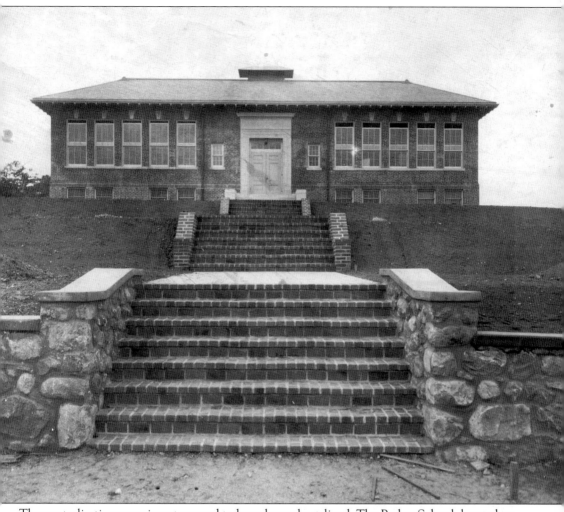

The centralization experiment seemed to have been short-lived. The Parker School, located on Bedford Street, was built in 1920 and was said to have the "charm of an old house." As a district school, the Parker School offered its students a comfortable and intimate learning environment. All the students walked to the school (none lived more than a mile away), and the teachers knew most of the parents on a first-name basis. Parker closed in 1978, when the school-age population decreased and the school committee decided that its facilities were antiquated. Indeed, one structural disadvantage was that the boys' bathroom and the lunchroom were adjacent, mixing eating with unappetizing odors. When it closed, some 192 students were enrolled.

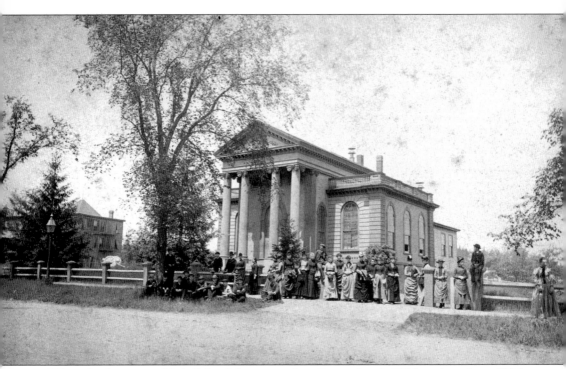

When the Lexington High School first opened on September 4, 1854, with a class of 20 boys and 10 girls, the school offered courses in Latin, French, history, rhetoric, natural sciences, arithmetic, and geometry. Extracurricular activities included the *Scholars Offering,* the weekly school newspaper containing editorials, articles, and original artwork from students. The school was located in the second floor of this Lexington Town Hall building. A large stove occupied one corner of the crowded classroom, consuming a lot of fuel and heating only a small portion of the space. The poor lighting and ventilation added to discomfort. When the Lexington Town Hall moved to a new building in 1871, the school expanded downward from the second floor to fill the whole building.

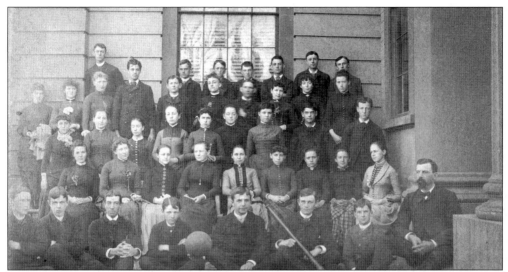

Admission to the Lexington High School in 1872–1873 was open to students who had completed primary, intermediate, and grammar grades and had passed an entrance exam. Questions on the exam included "Find the square root of 6561 and explain the process" and "Name the dates, causes, and results of the French and Indian War." With this academic training, the high school graduated Lexington's first group of eight students ready for college in 1875. In 1910, the New England College Entrance Certification Board accepted Lexington High School. This gave Lexington High School graduates the privilege of entering any New England college without an entrance exam. Shown here is the Class of 1887. On the far right sits J.N. Ham, high school principal and superintendent of schools. He was appointed to the superintendency the previous year while serving as principal. Under his administration, he discouraged the traditional pedagogy of learning by rote and instead encouraged students to explain thoughts in their own words.

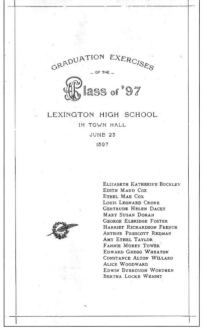

GRADUATION EXERCISES
... OF THE ...

Class of '97

LEXINGTON HIGH SCHOOL
IN TOWN HALL
JUNE 23
1897

Elizabeth Katherine Buckley
Edith Maud Cox
Ethel Mae Cox
Louis Leonard Crone
Gertrude Helen Dacey
Mary Susan Doran
George Elbridge Foster
Harriet Richardson French
Arthur Prescott Redman
Amy Ethel Taylor
Fannie Morey Tower
Edward Gregg Wheaton
Constance Alton Willard
Alice Woodward
Edwin Burrough Worthen
Bertha Locke Wright

The Lexington High School graduation exercises were held in the town hall in 1897. The graduating class of 16 contrasts sharply with the 376 graduating seniors in the Class of 2001. This group required Tsongas Center in Lowell for an indoor space.

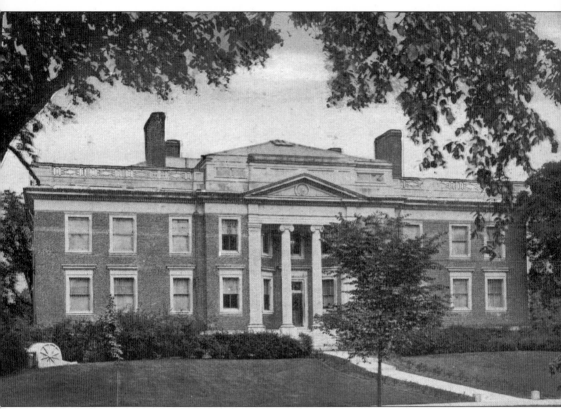

In spite of expansion to the lower floor in 1900, state inspectors rated the Lexington High School's condition in the old Lexington Town Hall as "highly unsatisfactory." In 1902, this new high school was built on the same site as the previous 1847 town hall. In 1925, the eastern end of this building was expanded to accommodate a new high school, grades 10, 11, and 12. The original western end became a junior high school, grades seven, eight, and nine. Today, the building houses condominiums. By 1931, the student population had nearly doubled. Regardless, a proposal for another school construction was heavily rejected in part due to the onset of the Great Depression. The school committee finally went ahead with the construction in 1951 that resulted in the main Lexington High School building standing today. The campus has added buildings since and is currently undergoing a major renovation.

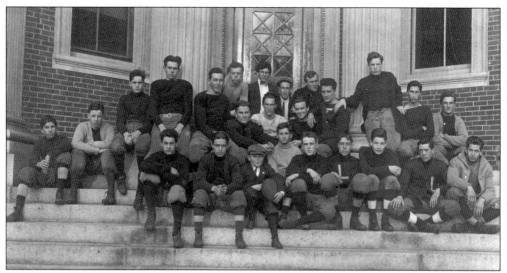

The Lexington High School football team poses on the high school steps in 1912. The school budget in 1911 allocated money for a football coach for the first time. Previously, the coach was funded through private subscriptions. At the time, team members usually played both offense and defense. Although this may not have been by design, playing both ways reduced the need for large teams.

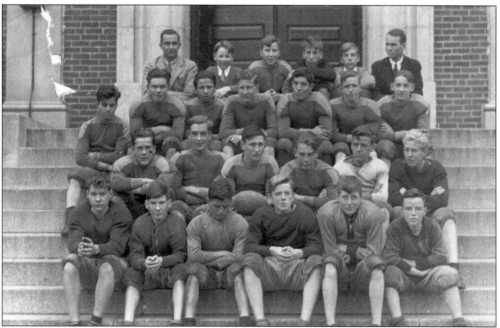

The 1939 Lexington High School football team began the season with a 39-0 loss against Winchester. This began an unfortunate trend throughout the season as they finished the first six games without scoring a point. The team salvaged the season, however, when it claimed its first victory in five years on Thanksgiving Day against Concord. To honor the team's achievements, a group of Lexington citizens planned a banquet, held on December 13, 1939, at the Masonic Hall. About 120 men and boys attended the turkey dinner to celebrate the town's "losing yet successful" football team.

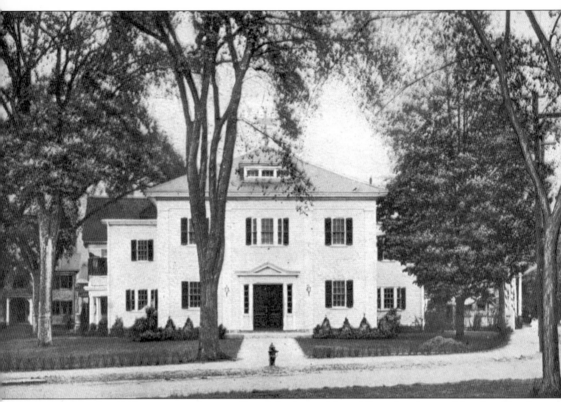

Early in the 19th century, due to dissatisfaction with public schools, wealthy families in Massachusetts began to enroll their children in private schools. As part of this trend, a charter was granted to establish the Lexington Academy in 1822 "for the purpose of promoting religion and morality and for the education of youth in such of the liberal arts and sciences." A committee oversaw the school's construction on Hancock Street, today the Masonic temple. Eighty-four students began its first academic year in 1823. Many of these students traveled from other states and boarded with local families. Seventeen students came from Lexington. The early graduates even formed the Lexington Academy Association, which held reunions for many years after the academy was discontinued in 1833. At that time, Austin Chittenden acquired the property and established the Lexington Manual Labor Seminary, designed for industrial education.

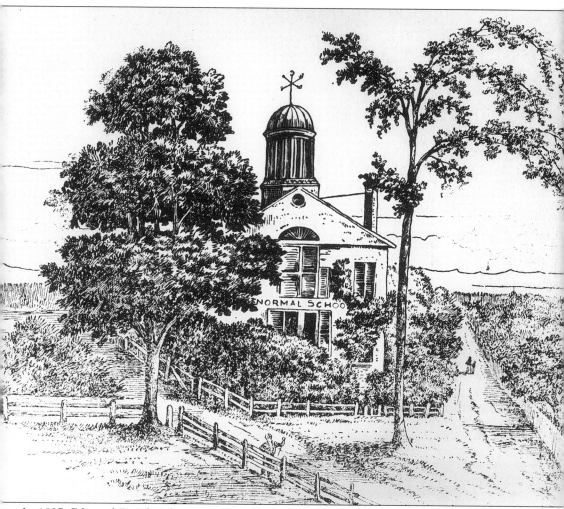

In 1837, Edmund Dwight of Boston offered $10,000 to the Massachusetts Board of Education for a normal school in Massachusetts. Housed in the building built for Lexington Academy, the Lexington Normal School became the first state-funded teacher training institution in the nation. When it opened on July 3, 1839, only three young women arrived, but the school later flourished to the point that it outgrew Lexington's facilities. It moved to Newton in 1844. The building included a kitchen, dining room, washroom, and storeroom in the basement; a classroom and sitting room for the boarders on the first floor; and five dormitories and a school room on the second story, with four more dormitories in the attic. The town also equipped the school with two stoves, two maps, a pair of gloves, and a small library of about 100 books, all valued at $600–$800. The building could serve 20 boarders and 80 students. Boarders had to pay $2 per week, but the tuition was free. This is an engraving of the building at the time. Bedford Street passes on its left while Hancock Street passes on its right. A fence surrounds the the common in the lower left-hand corner.

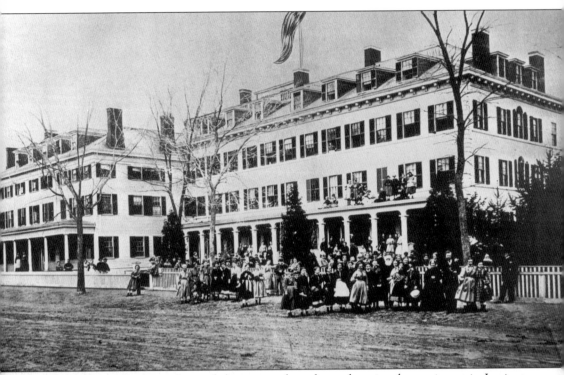

Dr. Dio Lewis, both teacher and doctor, conducted an educational experiment in Lexington called Dr. Lewis' School for Young Ladies. A retrospective article in the *Lexington-Times Minuteman* in 1930 notes that when he began his teaching career, he was considered by many to use radical teaching methods because he kept order with "gentle manners and worked with [students] outdoors and even sang them songs." He practiced medicine outside New York City, one of the first easterners to practice homeopathy. In 1864, Lewis bought the Lexington House to convert it into a school for young ladies. What distinguished this school from others was Lewis's emphasis on physical education for girls. He found exercise led to better health. In the four years of the school's existence, 300 young women from throughout the United States, Central America, and the West Indies attended. Catherine Beecher numbered among the distinguished teaching staff.

Dio Lewis's school was advertised especially for students who had "broken down" at other schools, and, thus, many students at first entered his institution to be treated as patients. The girls followed a very regular schedule—they ate simple food, practiced gymnastics for an hour daily, danced three to four evenings per week, and went to bed at 8:30 p.m. Historian Charles Hudson writes that this routine elicited "a glow of health so essential in those who are to become the mothers of the next generation." With his innovative educational methods, Dio Lewis's school earned a nationwide reputation. Unfortunately, on September 7, 1867, the building burned down, and Dr. Lewis, despite his intentions to continue his school in another building, never found another one suitable for the purpose. Shown here are some of his scholars in transit.

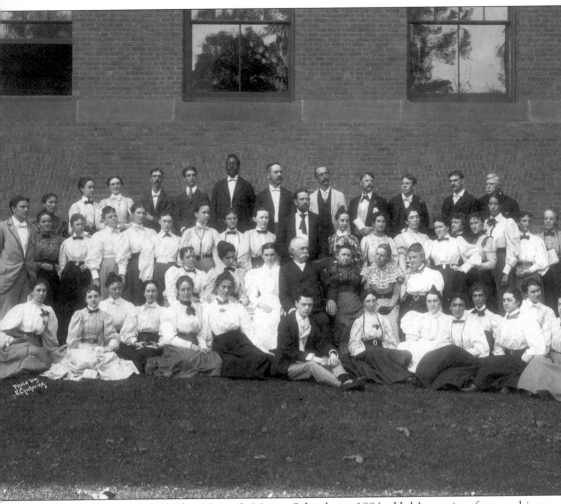

H.E. Holt established the Normal Music School in 1884. Holt's genius for teaching revolutionized the method of music instruction. Until Holt, musical instruction in America had largely depended on rote singing and materials adapted from German textbooks. According to Charles Hudson, Holt had "a foresight which might be characterized as prophetic" when he published a series of textbooks called *The Normal Music Course* to be used at his school. The Lexington Summer School of Music was established to train supervisors and teachers with these new books. Within a decade, other music courses modeled on the ideas of Holt's textbooks developed. In the early 1890s, the school's name was changed to the American Institute of Vocal Harmony and, in 1899, its population reached 100. The school continued to flourish until Holt's death. Classes were conducted at the Hancock School.

Four
PROVIDING LEADERSHIP

Pastor of First Parish Church for 50 years (1755–1805), Jonas Clarke was perhaps the most politically influential Lexington citizen during the Revolutionary War era. Related by marriage to John Hancock (his ministerial predecessor and grandfather of the future governor), Clarke prepared the town for the coming conflict from his pulpit. Historian Charles Hudson has called him "politically religious and religiously political." As testimony to his political acumen, Reverend Clarke represented Lexington at the Massachusetts Constitution ratification convention in 1779.

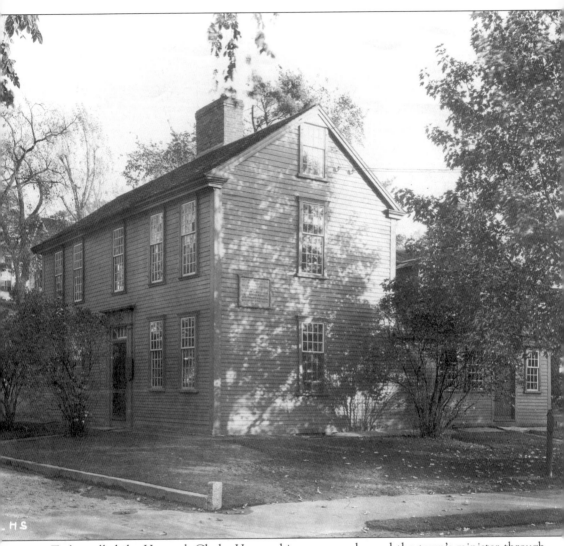

Today called the Hancock Clarke House, this parsonage housed the town's minister through Jonas Clarke's pastorate. Between them, John Hancock and Jonas Clarke served Lexington for over 100 years. On April 18, 1775, Paul Revere arrived at Clarke's parsonage to warn Sam Adams and John Hancock of the British approach. Hancock (grandson of the former minister and related to Clarke by marriage) and Adams, leaders in the patriot cause, fled to what is today Burlington. In 1896, the Lexington Historical Society saved the parsonage from demolition by purchasing it and moving it across the street (shown here at that location). The owner of the original site, Ruth Brigham Jackson, left it to the historical society in her will in 1963. The parsonage was therefore returned to its original site in 1974. Today, it operates as one of three historic houses open to tourists.

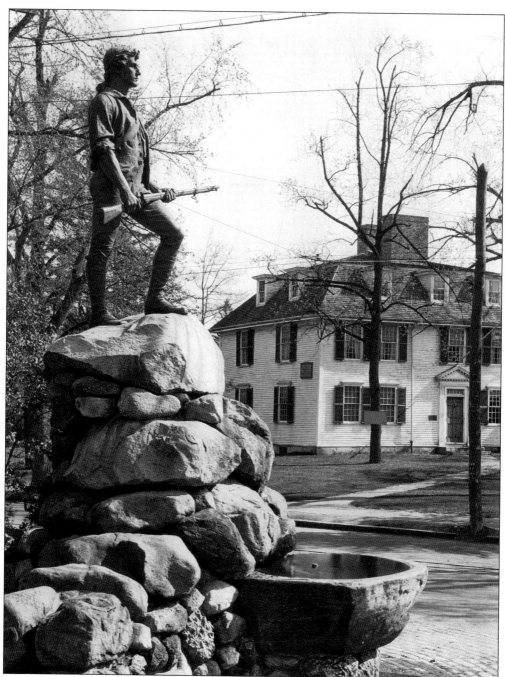

The leader of the militia company on the Lexington Green on that fateful April morning, Capt. John Parker led the men honored by the statue that stands prominently at the eastern edge of the Lexington Green today. The sculptor, Henry H. Kitson, used Medford resident Arthur Mather as a model for this memorial to the Lexington militia. Parker's steady command on that day earned him the respect of his men. A simple farmer whose property stood near Spring Street, Parker showed a fondness for books, often borrowing from Jonas Clarke's collection. Due to a lingering illness, Parker died six months after the battle.

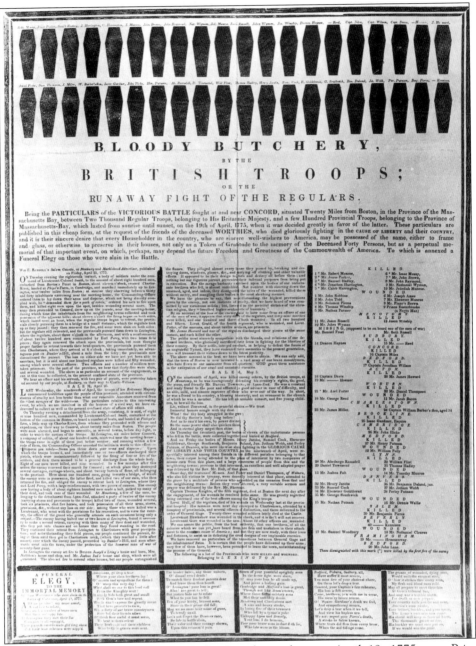

Standing with the militia as it faced the British regulars on April 19, 1775, was Prince Estabrook, age 34, slave of Benjamin Estabrook. This broadside lists the killed and wounded among those who participated in the day's fighting. Estabrook was among the wounded. He later enlisted in the Continental Army and served at Fort Ticonderoga. Alice Hinkle writes that among 215 soldiers enlisted in Lexington, at least nine were African American, although some may have been nonresidents mustered in Lexington. After the war, Prince Estabrook returned to the Benjamin Estabrook farm and appears to have been freed. It is possible his service earned his freedom, a common recruiting incentive in New England colonies. Estabrook later moved to Ashby, Massachusetts, where he is buried.

William Munroe commanded the militia detachment standing guard at Jonas Clarke's home on April 18, 1775. He was charged with protecting Clarke's guests, John Hancock and Samuel Adams. After Paul Revere's warning, Munroe led them to safety. He later served as a lieutenant under General Gates at Saratoga in 1777 and eventually rose to the rank of colonel in the Middlesex militia.

When Jonathan Harrington Jr. died on March 26, 1854, at age 95, he was the last survivor of the Battle of Lexington. He served as fifer under Captain Parker. Harrington's passing called for an elaborate funeral attended by the governor and lieutenant governor as well as many members of the state Senate and House of Representatives.

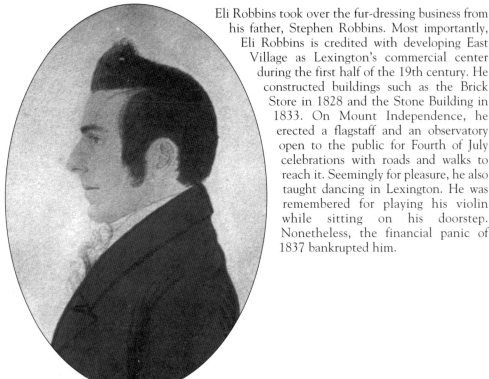

Eli Robbins took over the fur-dressing business from his father, Stephen Robbins. Most importantly, Eli Robbins is credited with developing East Village as Lexington's commercial center during the first half of the 19th century. He constructed buildings such as the Brick Store in 1828 and the Stone Building in 1833. On Mount Independence, he erected a flagstaff and an observatory open to the public for Fourth of July celebrations with roads and walks to reach it. Seemingly for pleasure, he also taught dancing in Lexington. He was remembered for playing his violin while sitting on his doorstep. Nonetheless, the financial panic of 1837 bankrupted him.

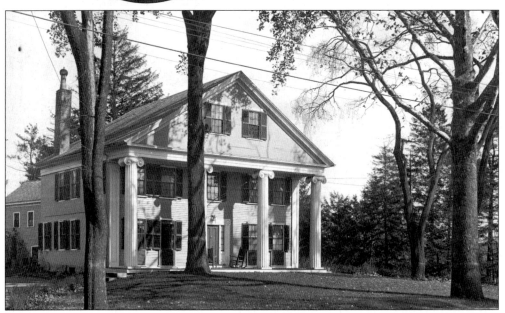

This Greek Revival–style East Lexington estate was named for French immigrant N. Ambrose Morell. Built by Obadiah Parker in 1803, the property was acquired by Morell some time after. A veteran of Napoleon's second campaign in Italy, Morell arrived in Lexington before 1798 and entered the fur trade. He added pillars, a long porch, and a second floor in 1839. Later, the house became known as the Dana Home, for Ellen Dana, Morell's granddaughter.

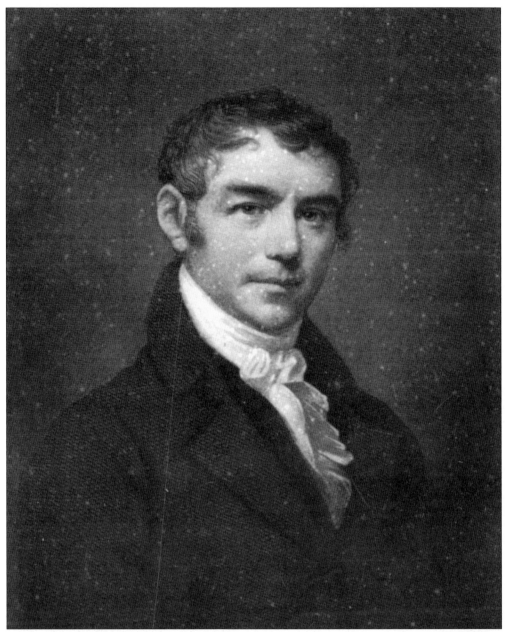

Born in Cambridge on June 10, 1753, William Eustis had moved his family to Lexington in time to stand with Captain Parker on April 19, 1775. He later served as physician and surgeon after studying medicine with the patriot Dr. Joseph Warren. After the war, Eustis rose to prominence as a Massachusetts state legislator, U.S. congressman, and secretary of war during President Madison's first term (1809–1813) and ambassador to Holland during his second (1814–1818). While in Europe, he renewed a friendship with Marquis de Lafayette and later entertained him at his mansion in Shirley, when Lafayette visited the United States in 1824. After returning to Congress from 1820 to 1823, Eustis was elected governor of Massachusetts in 1823, but, soon after, he caught pneumonia and died in 1825. He is buried in the First Parish Cemetery. His friend Edward Everett wrote the inscription on the monument.

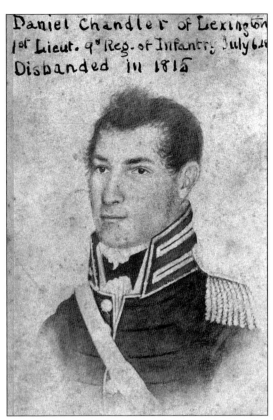

Daniel Chandler of Lexington 1st Lieut. 9th Reg. of Infantry July 6.. Disbanded in 1815

Daniel Chandler, shown here in 1813, became first lieutenant in the 9th Infantry Regiment during the War of 1812. Once the war ended, he resigned his commission to assume the superintendency of the Farm School on Thompson's Island and later supervised the Boston House of Reformation. In 1831, he constructed the first hothouse in Lexington, in which he cultivated passion flowers, fig and orange trees, and hydrangeas.

Born in 1794, Caira Robbins was the daughter of Abigail and Stephen Robbins, a wealthy East Village fur dresser. Educated in private girls' schools, Robbins had the privilege of traveling throughout the northeastern United States, including the newly constructed Erie Canal, which she called "the Grand Canal." When she died in 1881, she bequeathed $50 and an impressive private library of several hundred volumes for a "public-reading room" to be established in East Lexington. In 1885, Cary's East Branch Library opened.

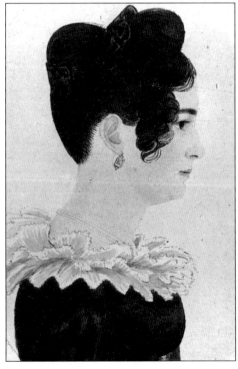

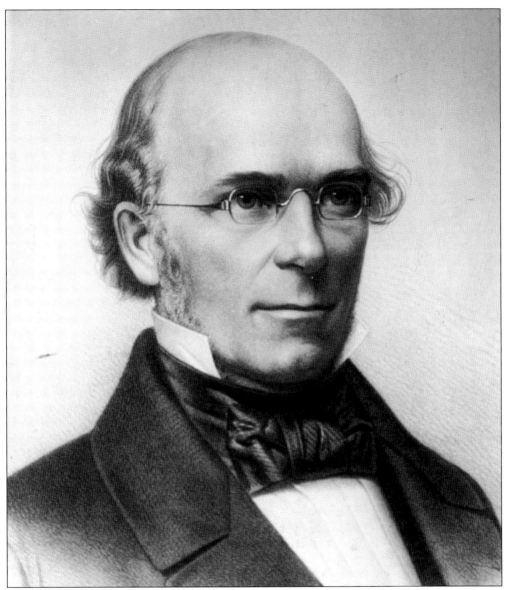

Abolitionist and the most prominent Unitarian minister of his time, this grandson of Capt. John Parker is among the most distinguished of Lexington's natives. At age 26, Theodore Parker ministered to his first congregation in West Roxbury. Soon, Parker's oratorical skills and politics brought him into prominence. Somewhat brusque in manner, Ralph Waldo Emerson said at Parker's memorial service in 1860 that he "never kept back the truth for fear of making an enemy." During Boston's resistance to the return of fugitive slave Anthony Burns to Virginia in 1854, Parker addressed a packed Fanuiel Hall protest meeting. After contracting tuberculosis, he left the United States for warmer, healing air and died in Florence, Italy, in 1860. While abroad, Parker's name became involved in the investigation of John Brown's attempted slave uprising at Harper's Ferry. Parker was named as one of the Secret Six, prominent abolitionists who had financially supported Brown. Samuel Gridley Howe and his wife, Julia Ward Howe, received an unusual memento after their friend's death. The physicians in Florence sent Parker's brain in a floating in a jar.

Elias Phinney is best known for his published account of the Battle of Lexington. Controversy over the militia's steadfastness on the Lexington Green arose in 1824, when Samuel Hoar of Concord claimed in a speech that his town made the first "forcible resistance" to the British. To refute the charge, a committee was appointed to collect evidence from survivors, and Phinney wrote a 40-page pamphlet based on its findings.

Cyrus Pierce, a Unitarian minister, became the principal at the Lexington Normal School in 1839, the first of its kind in the United States. Normal schools were teacher training institutions, a response to a growing belief that teachers needed specialized training beyond knowledge of subject matter. An innovator, Pierce established what today would be called a laboratory school with his prospective teachers practicing the principles of teaching on local children. Pierce resigned in 1842 for health reasons. When in 1844 he resumed his leadership of the school, it had outgrown the building that housed it.

Yours truly.

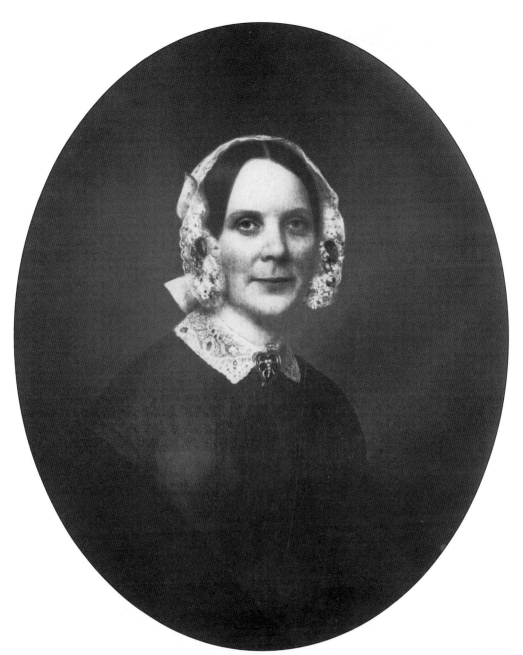

Maria Hastings Cary was one of the family benefactors, to whom the town owes so much. She donated $1,000 in 1868 to found a library. This library opened in an upstairs room of Whitcher's Store. One year later, she offered $6,000 for a memorial hall in the proposed new Lexington Town Hall. Before she died in 1881, Maria Hastings Cary donated $21,000 for the library, $10,000 for a memorial hall, and $4,000 to the new Lexington Town Hall building. Her philanthropy enabled the Cary Memorial Library to be built. Also, she financially assisted in returning to Lexington the Massachusetts building of the 1876 Philadelphia centennial, which opened here as a hotel called the Massachusetts House.

Though not legally adopted, Alice Butler Cary was considered the adopted daughter of Maria Hastings Cary and William Harris Cary. In 1905, the land the Cary Memorial Library occupies was donated by Alice Cary in her parents' name. During her tenure at the Cary estate, she expanded the property and built the Cary mansion. It burned in 1895, and she immediately rebuilt it. Alice Butler Cary died on January 11, 1911.

Isaac Harris Cary was William Harris Cary's brother and partner in an import company. With branches in Boston and New York, the company was so successful that at William's death, it was the largest importer of fancy goods in the country. Isaac lived in Boston but summered in Lexington with his family. In their wills, his daughters, Susanna E. Cary and Eliza Cary Farnham, bequeathed an enormous sum of money in Isaac Harris Cary's name. It financed the Cary Memorial Hall, the ongoing Cary lecture series, and the Isaac Cary Education Fund.

Nathaniel Pierce proved a stalwart of the Lexington milk business. For 50 years, he carried milk into Boston every day except Sunday. His July 5, 1879 *Lexington Minuteman* obituary notes that in his 90-year life, "the service of a physician had never been required, except in one instance of a brief attack of rheumatism."

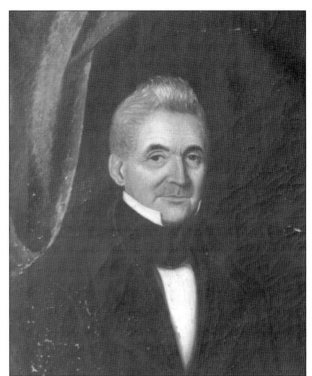

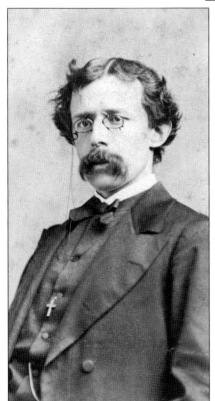

The first pastor of the Hancock Church, Edward Griffin Porter ministered to a congregation of 24 once he was ordained in 1868. Educated at Harvard and Andover Theological Seminary, he also studied abroad. As pastor, he continued to tour with the American Board of Foreign Missions. Reverend Porter's interest in missions made Hancock Church a leader in the international field. School committee membership and service as the Lexington Historical Society's first corresponding secretary were among the civic duties he performed before resigning his pastorate in 1891.

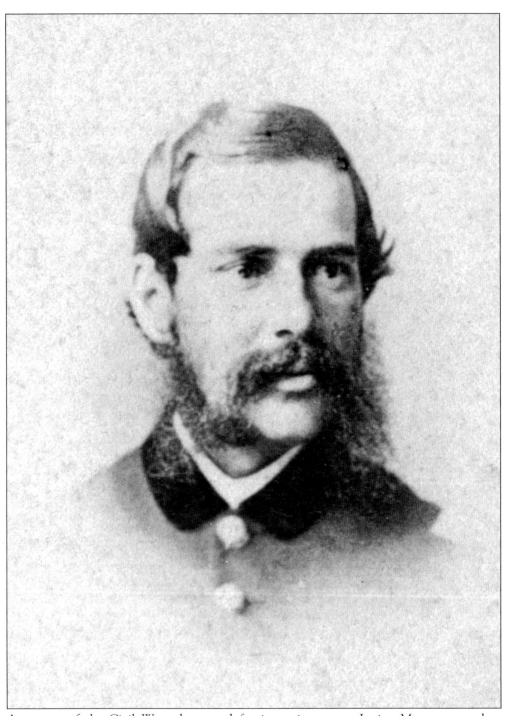

A veteran of the Civil War who served for its entire course, Loring Muzzey entered as quartermaster and rose in rank to brevet major and commissary of subsistence. As such, he was responsible for providing rations to Robert E. Lee's starving army after the Confederate surrender at Appomattox. For Lexington's centennial celebration (1875), Muzzey commanded the newly constituted Minuteman company. From 1898 to 1908, he served as town tax collector.

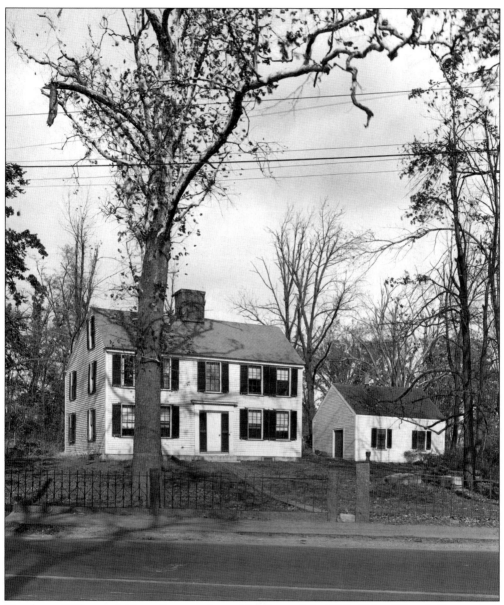

Daughter of Ellen and Abner Stone and granddaughter of the Eli Robbins, Ellen A. Stone came from progressive and eccentric stock. The members of the Robbins side of the family were fervent abolitionists. Born in 1854, too late for a crusade to end slavery, Stone took an interest in rural southern schools and women's progress. Highly educated, she studied law and passed the bar exams. She became the first elected female member of the school committee in 1887. In 1892, she presented the Stone Building to the town, where today it houses the East Branch Library. Ellen A. Stone resided in the family homestead, purchased by Stephen Robbins, shown here, on the corner of Massachusetts Avenue and Pleasant Street (since moved to 1295 Massachusetts Avenue). She lived up to the eccentric reputation of her family. In 1879, Stone wrote a series of letters to the *Lexington Minuteman* protesting the town's prohibition against her cutting down a tree near her land. She finally hired workers to take the tree down early one morning only to be stopped when a crowd gathered. She died in 1944 at the age of 90.

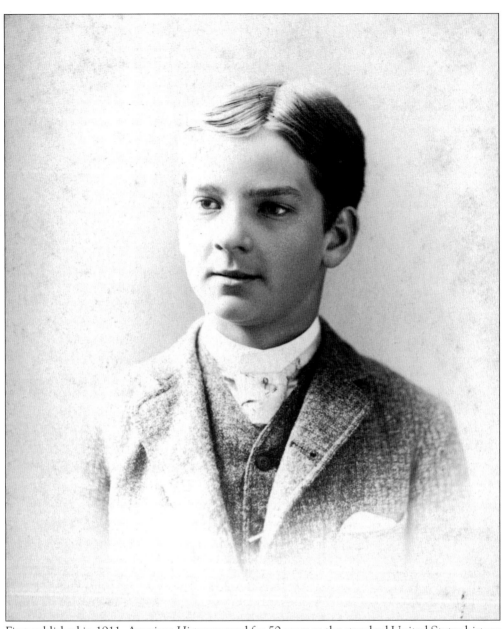

First published in 1911, *American History* served for 50 years as the standard United States history textbook. It is fair to say that a majority of Americans learned their nation's history from it. As recently as the mid-1970s, it was still in use. The author, David Saville Muzzey, was a Lexingtonian whose roots predate the Revolution. In 1711, Benjamin Muzzey sold land for a common and meetinghouse site. His grandson, Amos Muzzey, stood with Captain Parker on April 19, 1775. Earning an undergraduate degree at Harvard College in 1893, David Saville Muzzey pursued religious studies at Union Theological Seminary before turning to history. Muzzey earned his doctorate from Columbia University after studying at the Sorbonne and the University of Berlin. An author of several books, he served as professor at the Barnard School, Columbia University, beginning in 1911. He is shown here in his high school graduation photograph.

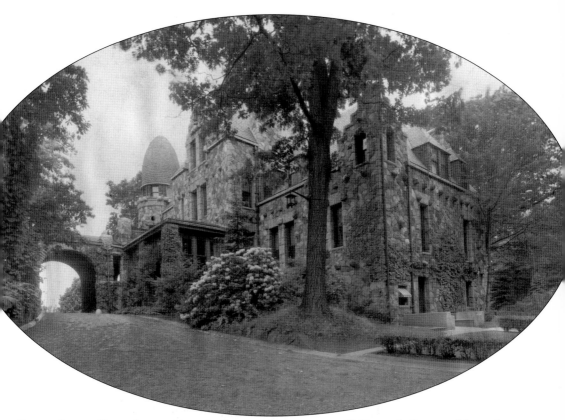

Francis Brown Hayes first purchased a house in Lexington at 45 Hancock Street in November 1861. He used it as a summer home. In subsequent years, Hayes acquired a number of smaller farms extending over Granny Hill to beyond Grant Street, until his estate consisted of nearly 400 acres.

From 1883 through 1884, Hayes built this five-story fieldstone mansion, later referred to as "the Castle," on present-day Castle Road. It was first occupied on Christmas Day 1884 and was torn down in 1941. This lavish Victorian stood as a monument to the wealth a new professional class brought to Lexington once the railroad made Boston accessible to commuters. The estate included a small natural pond near the top of the hill, as well as several varieties of rare and imported plants cultivated by Hayes. These included orchids, camellias, and rhododendrons. Hayes seemed to enjoy children. Once he invited every child in Lexington to a Christmas party, and his estate was known for Halloween parties for local children.

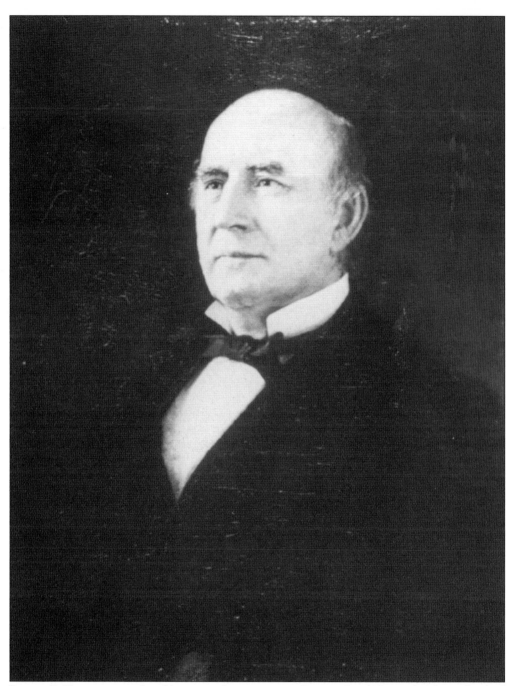

Francis B. Hayes was a railroad lawyer and state senator. Born in South Berwick, Maine, he died while seeking the Republican nomination for U.S. senator in 1884. Hayes also served as a state senator in the fall of 1873. The Hayes Castle, as it came to be known, was finished by his son Francis B. Hayes Jr. His $10,000 bequest to the town funded the Minuteman statue on the Lexington Green. This seminal Lexington monument, unveiled on April 19, 1900, is also called the Hayes Memorial Fountain. The space at the base is filled with flowers today, but it was originally used as a water fountain for "men, horses, cattle, and dogs."

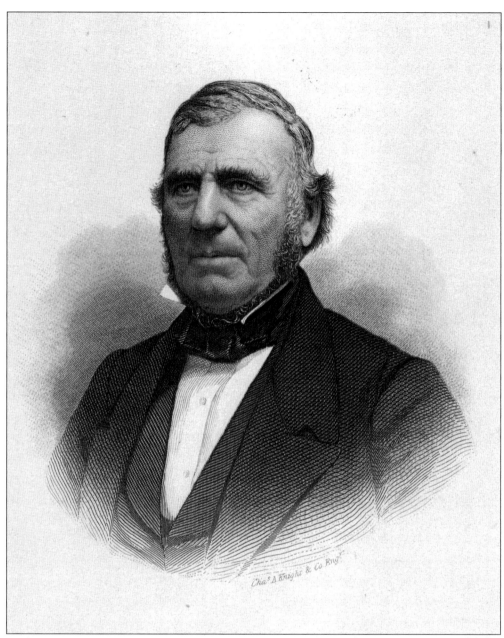

Author of *History of Lexington, Massachusetts* (1868, revised posthumously in 1913), Charles Hudson wrote what remains the town's only history. Particularly valuable is the second volume dedicated to genealogies. Hudson was born in 1795 in Marlboro and died in 1881 as one of the oldest War of 1812 veterans. While living in Westminster, he served for 10 years in the Massachusetts House of Representatives and Senate. He spent eight years in the U.S. House of Representatives. As a historian, he published histories of Marlboro and Hudson, a town named for him. He came to Lexington in 1849. A *Lexington Minuteman* obituary noted that "his fellow citizens here have always recognized him as a man fit to lead in all of the affairs of the town." He served Lexington in many capacities, including state legislature, selectman, school committee, and president of the Railroad Corporation.

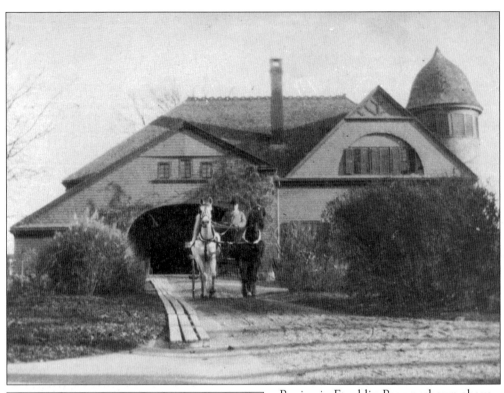

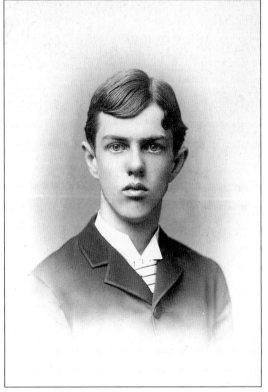

Benjamin Franklin Brown, shown above, was one of the new Lexington business class who moved here in the late 19th century. An insurance agent with an office on State Street in Boston, Brown lived a short distance from the common on Hancock Street. He later became the treasurer of the Lexington Water Company. His son Willard D. (left) became an architect and designed the Cary Memorial Library, as well as many of the houses built on Meriam Hill.

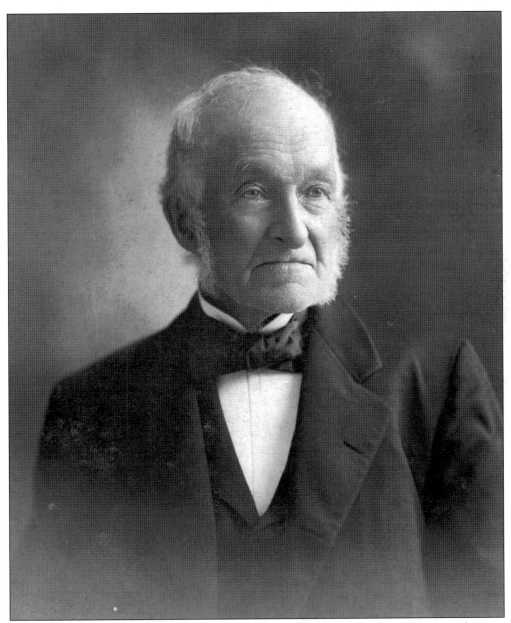

Albert Bryant served as selectman, assessor, and town clerk for 23 consecutive years and was an active member of the Lexington Historical Society. Born in 1814, he lived at the corner of Massachusetts Avenue and Marret Road. In 1890, the *Proceedings of the Lexington Historical Society* published his paper entitled "Lexington Sixty Years Ago," describing his neighborhood when he was a boy. In 1948, Edwin Worthen reminisced about the same neighborhood. He tells a family story of the Worthens' first day in Lexington with Edwin Worthen barely one year old. Upon arrival in a strange house, a loud knock on the door interrupted the family's packing. Standing at the door with a "great basket of fruit eggs and vegetables" was Albert Bryant. Worthen explains that his mother sat down on the floor and cried. Her gratitude was both for the basket and the knowledge of kindly neighbors. Worthen and the neighborhood always referred to Bryant as "Grandpa Bryant."

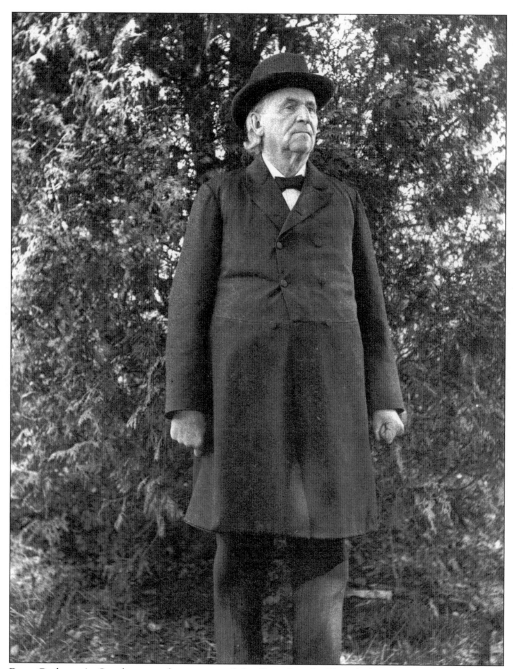

Rev. Carlton A. Staples served as pastor of the First Parish Church for 23 years (1881–1904). Having ministered to five previous parishes and to Union soldiers during the Civil War, Reverend Staples brought an experience seen necessary for a town undergoing many changes. One of the Lexington Historical Society's founding members, he served as its first historian and later president. His concern for preserving Lexington's past made a critical contribution. Reverend Staples is credited with saving the Hancock Clarke parsonage from demolition, pledging his own money and arranging for its relocation across the street. Today, it stands at its original location.

Daughter of Col. William Tower, Ellen Tower inherited his mansion after her brother Richard died 1921. Her devotion to ameliorating the suffering of children and the poor exemplified the noblesse oblige of the Progressive Era. In 1885, Tower supervised school playgrounds and became vice president of the Massachusetts Society for the Prevention of Cruelty to Children. So important was this contribution that a *Boston Transcript* obituary called her a "Boston playground pioneer." In 1901, she became chairman of a child welfare committee and director of the Visiting Nurse Association. Concerned that children have open spaces to enjoy, in 1928, she gave Lexington the parcel of land opposite her home, named for her father, William Augustus Tower Memorial Park. She wrote, "It seems important that we, of this generation should secure for those who come after us open space in our town. . . . If we do not do this our children will live in a noisy and crowded world, with no touch of nature and beauty."

Ambrose Morell's granddaughter, Ellen Dana, inherited his house, known since as the Dana Home. Edwin Worthen remembers her as a "gentle lady with all of the appearance of an aristocrat of the 1870s. Generous and kindly toward all." She left the estate to the Lexington Home for Aged People when she died in 1913. Incorporated in 1905 and led by Elizabeth Harrington, this organization had been searching for a suitable space to locate a rest home. After beginning renovations, the organization concluded that the renovation and maintenance costs made the Morell estate's use prohibitive. So, they sold it. The capital gained from the sale, however, enabled the purchase of the Reed family house on Massachusetts Avenue, near the town center, where the present Lexington Home for Aged People, or Dana Home, has been located since 1916.

In 1894, Levi Doran moved to Lexington from Brookline, Massachusetts, with his wife, Agnes Theresa Ryan, a native of Lowell. Doran began Doran's Farm with 25 acres of land, one windmill, one carriage, one cow, and three horses. Now, Doran's Farm has grown from a single greenhouse to a distinguished retail store. In this picture, Levi Doran is shown with his two grandchildren, Robert and David. Robert Doran is the father of Guy Doran, current owner of Doran's Farms.

Frederick L. Emery, shown here with son Leland in 1897, served as president of the Field and Garden Club from 1903 to 1934. Under his leadership, the club beautified Depot Park through planting and grading. When Emery died in 1937, he bequeathed $5,000 to the town, the interest to be spent under the direction of the Field and Garden Club. In the same year, the club placed a stone and chain fence around Depot Park. The park's name was changed to Emery Park in his honor in 1938.

In 1880, Edwin "Ted" Worthen came to Lexington at age one. For the next 77 years, he lived in and contributed to Lexington. An avid researcher of Lexington's history, he wrote the *Calendar History of Lexington, Massachusetts 1620–1946*, an essential resource. The Worthen Collection at the Cary Memorial Library—a collection of his correspondence, photographs, and acquired ephemera—is testimony to a life steeped in Lexington's history. Here he is shown sitting on the stairs in a photograph of the chamber of commerce in 1933.

S. Lawrence Whipple moved to Lexington in 1929 at the age of eight, found the community to his liking, and has remained there ever since. Considered the town historian, he has recorded conversations with many people, has taken hundreds of photographs, and has acquired many volumes relating to the town. His propensity for asking questions and his proclivity for writing have resulted in a lifetime caught up in local history. A frequent contributor to the *Lexington Minuteman*, he has a knowledge of Lexington that is unsurpassed.

Five

PUBLIC SERVICE, PUBLIC SAFETY

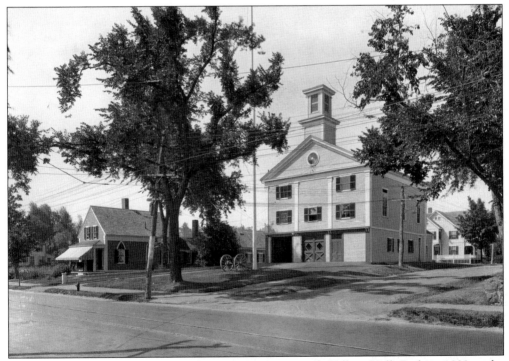

On the corner of Massachusetts and Locust Avenues stands Village Hall. Built in 1839 as the Church of the First Universalist Society, it also housed the St. Brigid parishioners before the town bought it. The ground floor was remodeled in 1873 to house the East Village Fire Department. The hall served as a community center, hosting plays, parties, and fairs. It also provided a meeting place for clubs.

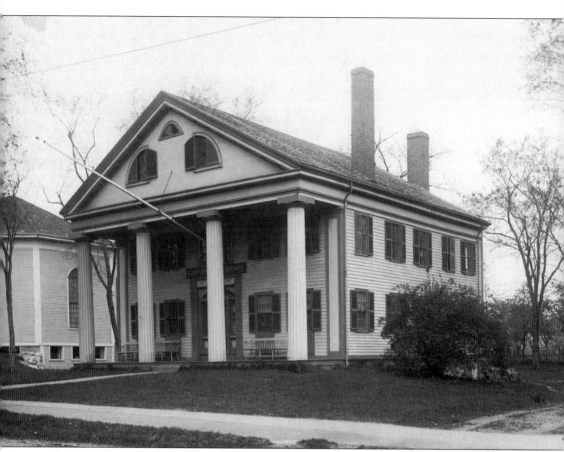

The Stone Building, shown here, was built by Eli Robbins in 1833 as a public hall for lectures and meetings. Robbins (an abolitionist at a time when such sentiment was unpopular) perhaps hoped to use the hall as a venue for inspirational antislavery orators. Used as a private school for two years, it later served as a meetinghouse for East Village parishioners prior to the construction of Follen Church. Notable ministers such as Charles Follen, Ralph Waldo Emerson, and Samuel May held services there. After Robbins sold the building, in the winter of 1846–1847, a lyceum lecture series brought Charles Sumner, Wendell Phillips, and Theodore Parker to the hall. It appears the prohibition against abolitionist topics remained in force at that time, but when Parker Pillsbury lectured in 1847, he directly addressed the slavery question. Abner Stone purchased the building in 1851, and his daughter Ellen Stone offered it in 1892 to the town as a library. Today, it is the East Branch Library.

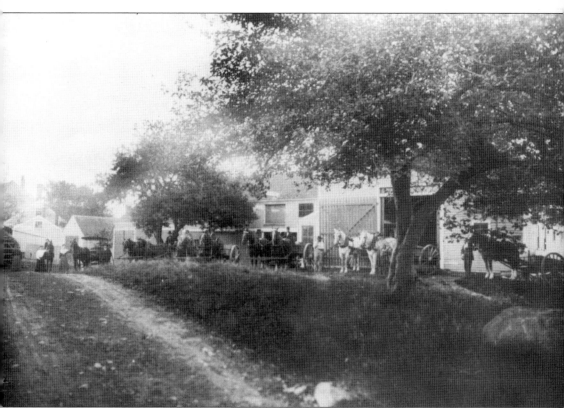

Lexington's first almshouse was located near the present Hayden Recreation Center. In 1845, the poor farm moved to the Hill Street location shown in this 1925 photograph. The farm provided work and shelter for its inmates and sold produce to the community to augment its funding. Annual reports document commerce between the Overseers of the Poor and the community. Inmate residence could be temporary or permanent, but was open only to citizens of the town, not drifters. Due to its financial burden to the town and the quality of new, state-run facilities, the Overseers of the Poor closed the farm in 1925. In 1930, the buildings were demolished. Today, the property is conservation land.

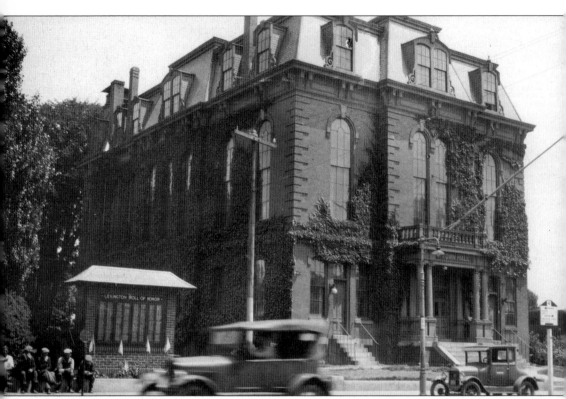

The construction of the second town hall, shown here in 1928, underscored the ongoing tension between East Village and Center Village. Beginning in 1867, any discussion surrounding a new town hall revolved around location. East Lexington citizens opposed the proposed location on Massachusetts Avenue opposite Waltham Street, in the area vacated by the Dio Lewis' School fire. The previous town hall building, built in 1847 by David Tuttle, is today the site of Muzzey Condominiums. East Villagers insisted any new location be even closer to them. Spurred by Maria Cary's $6,000 contribution for a memorial hall, work began in 1870 at the Center Village site. Undaunted, a small group of East Villagers halted construction with a court injunction. It cost the town $188.53 and a court appearance to lift the injunction. Not surprisingly, this did little for harmony between the two villages. Edwin Worthen writes in the early 1950s, "This bitterness never died and that certain old residents never entered the new town hall. The Adams Engine Company voted not to accept the selectmen's invitation to attend the dedication!"

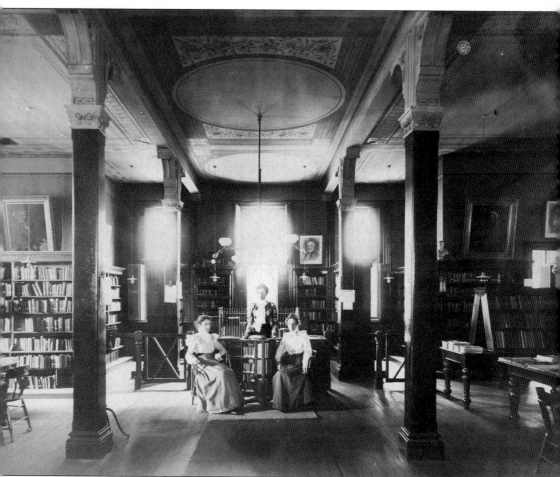

From 1871 until 1906, the rear of the Lexington Town Hall, shown here, housed the Cary Memorial Library. It had previously been located in a room above Whitcher's Store. An early catalogue sets the library's holdings at about 1,200 volumes. Only residents over 14 years of age were permitted to borrow books, and no one could take more than one at a time. The rules set late fees at 5¢ a day. In the library's first three months, town residents borrowed books on 1,670 occasions, about two-thirds of which were nonfiction. The holdings were organized into seven broad groupings: Agriculture and Horticulture, History and Biography, Poetry, Science and the Useful Arts, Travels, Fiction, and Miscellaneous.

The new Cary Memorial Library dedication on July 16, 1906, drew selectmen, trustees, and the building committee. The *Lexington Minuteman* on July 14, 1906, reported that the "simple ceremony" would include "a group of the donor's friends." Alice Butler Cary had donated the land, carrying on her adopted mother Maria Hastings Cary's work. Maria Hastings Cary had provided the seed money for a library before she died in 1887.

On October 18, 1928, Cary Memorial Hall was dedicated and the town offices moved to its present site. This photograph shows the old town hall being dismantled. A variety of stores filled the space it vacated.

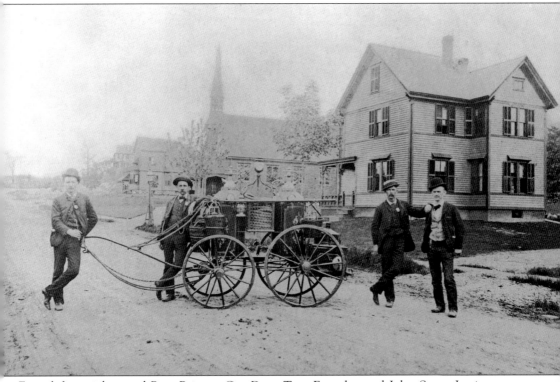

From left to right stand Russ Britton, Gus Dow, Tom Forsythe, and John Scott. Lexington purchased this chemical hand engine in 1874 for $750. Housed at Meriam Street Station, it used a new technology to create a pressurized flow of water. Equipped with soda, acid, and water, the substances mixed together creating gases in the tank that compressed the remaining liquid, producing a sizable stream of short duration. The chemical tanks required no labor to operate and proved very useful where the water supply was short. Not until 1894 did the first horses pull the engines. Instead, the firemen dragged engines to the site. Initially, the department borrowed horses when needed, but, at times, no horses were available, especially during plowing and harvesting seasons. In 1897, the department finally succeeded in acquiring horses from the town. To the department's disappointment, this had a catch. The selectmen insisted that the horses help water and plow the streets when needed.

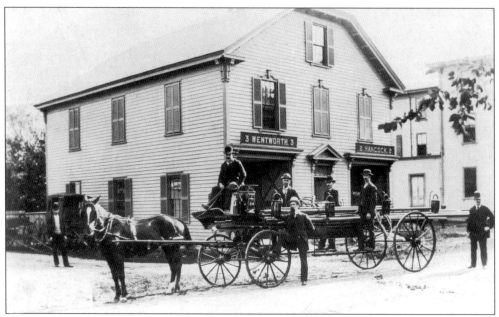

Lexington's first ladder wagon became part of the Meriam Street Station in 1875. Before that, all ladders had been fixed to the side of the latest fire truck. Consequently, they were short and only used for entering ground-floor windows or climbing a tree. The original wagon was hand drawn. This 1892 photograph shows the engineers. From left to right are John T. McNamara, Thomas Green, Willard Wolcott, B. Foster, and John Griffins. Ed Nourse stands on the truck toward the back with a soft felt hat. The man on the street is unidentified.

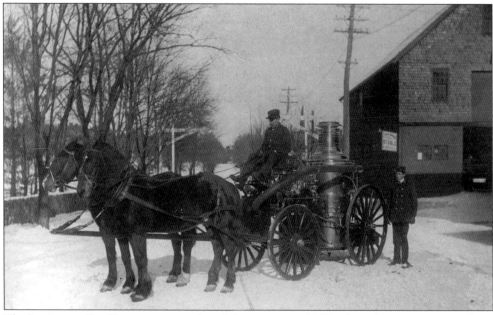

The Lexington Fire Department purchased this engine in 1895, after a long controversy about the need for a steam engine that could pressurize the water for the hose. The water from some of the hydrants was said to be easily stopped by the force of one's hand. Driving is William Wright. Percy Glenn is standing. The Meriam Street Station is in the background.

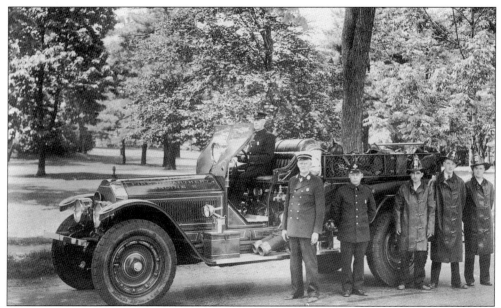

Here is the "finest rig of its era" in this *c.* 1928 photograph that shows Charles Richard, seated, with Selon A. Cook, John Lyons, Bill Meadows, George Glenn, and Jimmy Collins. Its most impressive features were its triple-combination pumper that could produce 750 gallons per minute and the fact that it carried a small water supply in its chemical tanks to begin fighting fire quickly. It revitalized a department with aging equipment.

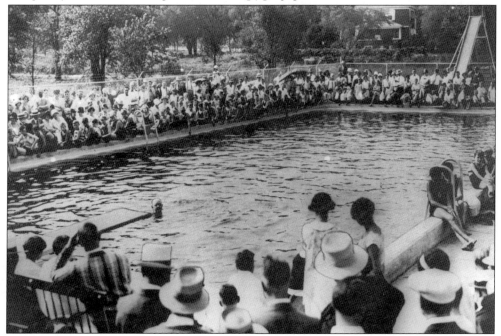

The town pool is packed with spectators who focus on the lone swimmer. Dedicated in 1929, it replaced the muddy wading pool at the Parker Street Playground as the best warm-weather alternative the town offered (the "res" was opened in 1970). The pool opened to the public on June 21, 1930. If this photograph is not of the event, it was taken soon after.

In a photograph probably taken around the beginning of the 20th century, Off. Patrick Maguire demands Peter Gillooly's peddlar's license in a funny staged scene. Beginning in the 1890s, the Irish, many first generation, worked in law enforcement in the town. In 1910, Maguire was shot stopping a burglary on Highland Avenue and continued to give chase until his ammunition ran out. Maguire's son Ned continued that family tradition as a Lexington police officer for many years.

Police chief James J. Sullivan poses at his desk on April 9, 1936. Patrick Maguire, born in Ireland, became police chief in 1922 until 1926. James J. Sullivan, second-generation Irish, served as chief from 1926 to 1943. Town reports reveal that most arrests during this time were for drunkenness or traffic violations.

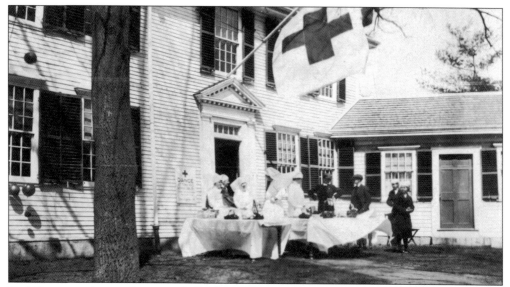

Red Cross members gather outside Buckman Tavern for Patriot's Day festivities in the 1920s. They had organized a dance as a fundraiser, the Red Cross flag flying above the entryway. Established as a branch in 1917 and a chapter in 1930, the Lexington Red Cross had since grown into a successful part of the Lexington community. In 1936, it raised nearly four times the expected quota, $1,952.63 instead of $500, and made sure each child in the town had shoes and rubber boots.

The Ice Storm of 1921 left trees, wires, and houses with an icy armor one full inch thick. Precipitation started on a Saturday afternoon, November 28, 1921, with snowfall that soon turned to a freezing rain not ceasing until Tuesday evening. Schools closed for the first three days of the week. The entire town was left without electric lights and telephone service with the exception of the center, which had underground wiring. On Tuesday alone, some 60 telephone poles crashed to the ground on Lowell Street. The streets were left in darkness for many nights after the storm.

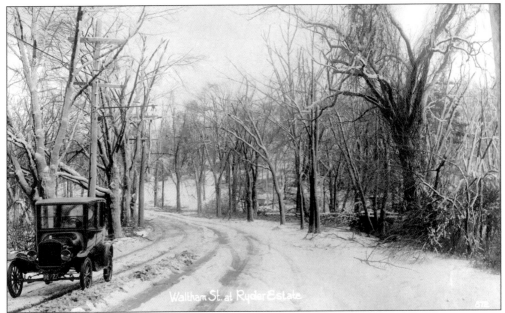

Waltham St. at Ryder Estate

The Ice Storm of 1921 left many prominent Lexington shade trees in tatters. Many lost their largest limbs and, in some instances, were ripped from the ground by the crushing weight of the ice. A fallen elm on Muzzey Street even crushed Lyman Lawrence's garage. The beautiful shade trees were once an identifying Lexington characteristic, and their damage saddened many people. On the other hand, with electricity out, the broken branches around town enabled residents to secure firewood.

Massachusetts Ave. from Waltham St. South East

Lexington residents pitched in to ameliorate the storm's wreckage. On Wednesday, many citizens patrolled the streets, picking up debris to make the roads passable. Even with their help, it took a few days before Lexington traffic ran as usual. Mail delivery was less frequent with some residents encountering frozen shut flaps on the mail drop-off boxes. In one notable case, a local patrolman testified in a Concord courtroom lit by candlelight, as the electric lights were out of commission.

In September 1938, a hurricane hit Lexington that rivaled some of the worst storms in Florida. Winds rose to unimagined levels, destroying 712 trees and damaging 1,854 in town. In cases like the Lexington Trust Company on Muzzey Street, shown here, the uprooted trees took the concrete sidewalks with them. The Hurricane of 1938 left the town in darkness the night of September 21, 1938. Boston Edison declared the damage was worse than that done by the Ice Storm of 1921, and, in case, Selectman Potter's two-floor pig houses on Walnut Street lost its roof and second-story walls. When Potter went outside to observe the damage, he was surprised to find 100 of his pigs sleeping peacefully in the wide-open second story. Apparently, the pigs were the least fazed of all Lexington residents.

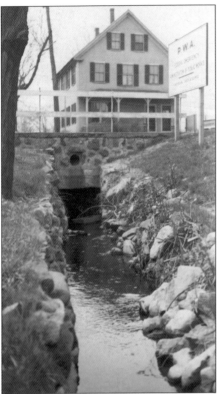

This culvert under Massachusetts Avenue is shown on May 15, 1939. Note the sign in the background reading, "P.W.A. Federal Emergency Administration of Public Works; The Brook, Drain & Sewer." The PWA, a New Deal agency devised as a stimulus to recovery from the Depression, funded construction projects throughout the country.

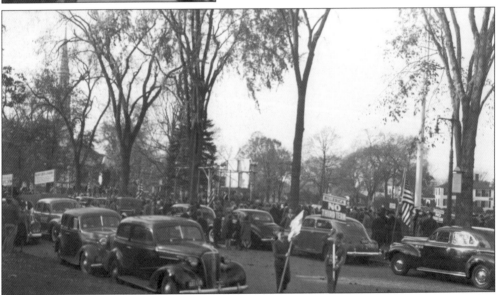

On October 23, 1940, a throng of 3,000 representing most towns within a 50-mile radius gathered on the Lexington Green to rally against a possible third term for Pres. Franklin Roosevelt. With buttons, signs, and even two oxen with "No Third Term" printed on their sides, protesters listened to Bainbridge Colby with enthusiasm. Colby was former secretary of state under the Wilson administration and roused the crowd to cheers with lines such as "Things are not wrong because they are forbidden. They are forbidden because they are wrong."

This two-alarm fire on 109 Massachusetts Avenue in East Lexington wreaked wintertime destruction on the property. In the 1890s, it had been the home of veterinarian Harry Alderman. This fire was one of 10 major ones in 1948, including the Cary mansion fire, in which firefighter George Whiting was fatally injured after falling 30 feet and fracturing his skull. It was a tragic year for the fire department.

In addition to purchasing war bonds to fund the World War I effort, Lexington citizens constructed this war chest. Located on the depot common, the structure included a large chest for donations with a reproduction of the Minuteman statue looming over it. A brochure for a two-week drive in May 1918 asked citizens to "give to Lexington's War Chest until the hinges creak." That drive raised close to $60, 000.

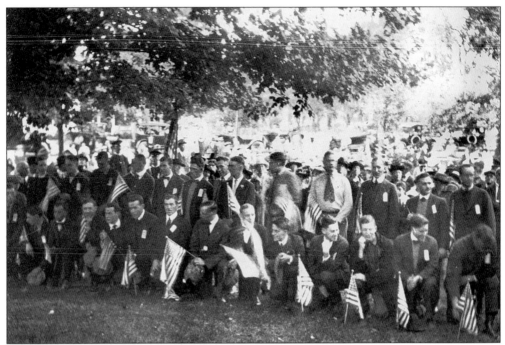

On September 17, 1917, town residents gathered on the green to send off Lexington's first quota of soldiers for World War I. Eight Lexington citizens gave their lives in the war.

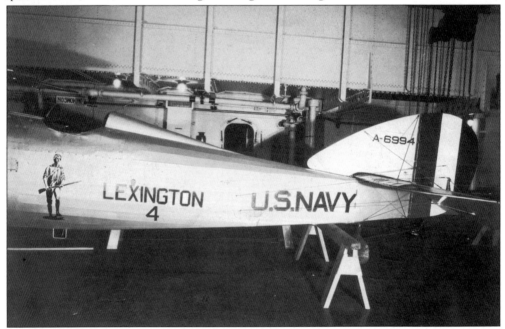

In 1942, the USS *Lexington* became the first aircraft carrier to be lost in World War II. Commissioned in 1927, it was one of the U.S. Navy's first two aircraft carriers capable of serious fleet operations. Shown here is one of the *Lexington*'s planes displaying its distinctive markings. In 1928, town representatives presented a silver service to the aircraft carrier in 1928 while it was at South Boston Dry Dock.

This was believed by many to be the first Aircraft Warning Service in the United States during World War II. It formed part of the U.S. Army's Post 38-K, organized on June 1, 1940. The tower itself was built in January 1942 on Robinson Hill. Posted in day and night shifts, 105 townspeople watched for German planes 24 hours a day. Pictures of German planes lined the walls to aid spotters. The post remained on active duty until October 4, 1943. The idea was conceived and instituted by Allen W. Rucker.

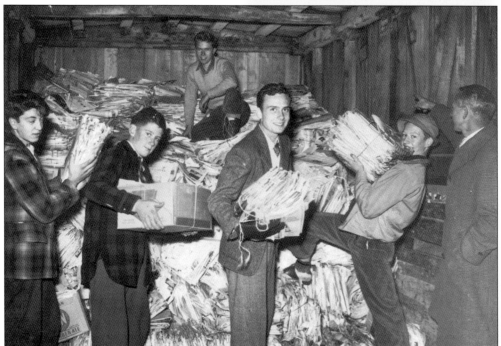

On this brisk day in late October 1943, members of the Junior and Senior Lexington High School collected old newspapers during the Waste Paper Salvage Drive. On the right, Principal Merrill F. Norlin oversees the operation. This was one of many contributions the Lexington home front made during World War II.

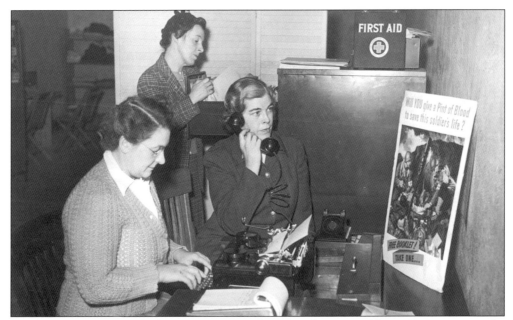

Red Cross volunteers worked to raise money and supplies during World War II. A poster on the wall bears the slogan "Will YOU give a Pint of Blood to save this soldiers life?" Mrs. Peter Kyle, Mrs. Robert Mayo, and Mildred de Bevard formed part of the successful Lexington chapter. During the war, they sponsored knitting and sewing for soldiers, collected food for the front, made bedside bags for wounded soldiers, and supplied cigarettes to hospitalized veterans. In May 1944, Red Cross urged residents to give pints of blood to commemorate the second anniversary of the USS *Lexington*'s sinking.

For Lexingtonians, the best part of the war was its end. Residents describe the end of the war as being full of songs and cheering. The Minuteman statue welcomes the World War II soldiers home.

Six

TIES THAT BIND

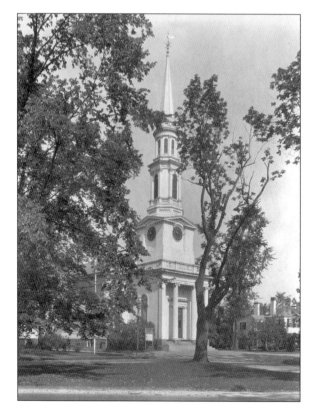

Facing the battle green, First Parish displays a sign with an inscription reading, "Every day is a fresh beginning, take heart with the new morning and begin again." This attitude led members of the Lexington community, then part of Cambridge, to petition the Massachusetts General Court in 1682 for their own parish. When granted a separate meetinghouse for Cambridge Farms, it was erected in 1692 on the Lexington Common. At the time, the words *church*, *parish*, and *town* were often used interchangeably. Residents were taxed for support of the church and ministers. At the outset a Congregational church, it later became Unitarian.

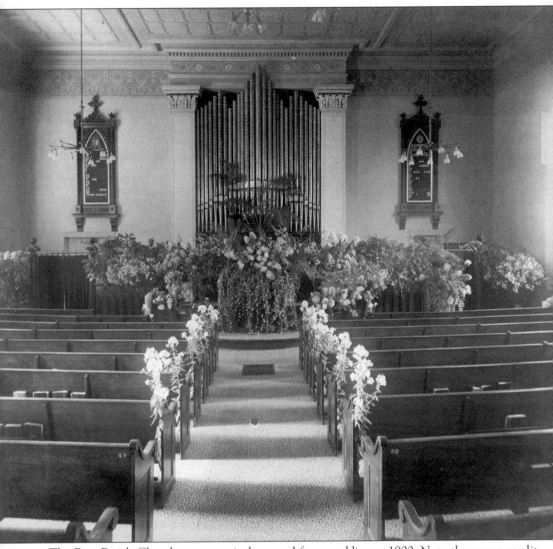

The First Parish Church sanctuary is decorated for a wedding c. 1900. Note the sparse gas-lit chandeliers and the heating grate in the center aisle. The church had been renovated in 1898, placing the organ at the front. First Parish was still paying organ blowers to pump air into the organ so that it would make sounds when played. The three organ blowers were paid a total of $23.27 in 1898 for their duties. The new organ and alterations themselves cost $4,619.52. That seems like an insignificant amount today, but, at the time, the cost created, in the words of the parish officers, "quite a debt for the society to pay." A story surrounding the organ position change involved a Mr. Battison. Before 1898, the organ was in the back balcony, and when the congregation rose to sing, they turned around to face the gallery. As long as Mr. Battison attended church, however, he turned to face the back during the hymns.

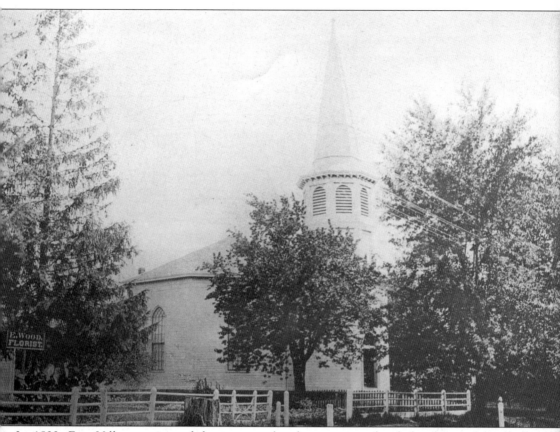

In 1833, East Village petitioned for its own church, as it considered the three-mile trek inhabitants made to reach First Parish in the center an unfair imposition. The village was refused, but with Charles Follen's support, the village raised its own money to strike out on its own. Beginning in 1835, the Stone Building held services with Follen as minister and other distinguished clergy, such as Ralph Waldo Emerson and Timothy Dwight, occasionally substituting. In 1839, Follen began to actively aid in raising funds for a building. It was completed in 1840. Follen planned to give the dedication sermon but died on the return journey from a speaking engagement, when the steamship *Lexington* sank. Not knowing of his fate, his wife and the parishioners dedicated the building without him. The church was originally called the Second Congregational Society of Lexington, but, in 1885, Mrs. John Beals bequeathed it $3,000 on the condition that it rename itself Follen Church.

Follen Church, an eight-sided building constructed in 1840, prefigured the octagonal style in domestic architecture that was made popular by Orson Squire Fowler in 1848. Fowler felt the style conformed to nature's forms by being close to a sphere. In addition, it had the practical advantage of providing more space and being easier to heat. Until 1906, the room under the octagon had a mud floor and was used as storage space for tools for East Lexington road repairs and fire apparatus. When the parish wanted to build an addition to absorb its increasing activity, the challenge of adding to an octagonal building was so perplexing that the Harvard Graduate School of Design produced 33 different plans, from which the parish chose.

While Baptists had lived in Lexington since at least 1781, in 1833, Rev. O.A. Dodge became the pastor for the first Lexington congregation. In the same year, a church was built for his ministry. Having more options sometimes divided families on Sunday. Alice Goodwin remembered in 1909, "Mrs. Tidd was a constant attendant, and her husband, who was a Unitarian, escorted her to the door." A fire in 1891 destroyed the original building. The Baptist Church's present home on Massachusetts Avenue is shown here.

Bostonians who summered in Lexington established the Church of Our Redeemer in the 1880s. Dr. Robert Lawrence led the first ceremony in his home in 1883. The first church was located at the corner of Meriam and Oakland Streets. Having moved across the street, the Episcopal church is currently located at the corner of Meriam Street and Patriots Drive.

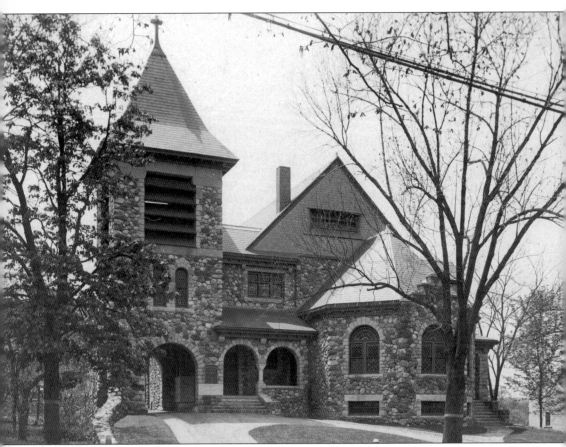

The stone fortress overlooking the Lexington Green is the Hancock Congregational Church. The roots of the congregation's creation can be found in the Unitarian movement of the early 19th century. Like many New England Congregational churches, the movement had caused a theological split at the First Parish Church. Unlike many churches with similar divisions coexisting within the congregation, First Parish became totally Unitarian in 1819, leaving without a church those interested in continuing the more orthodox Congregational approach. This led to the organization of the Hancock Church in 1868. Its first pastor, Edward Griffin Porter, began preaching on October 1, 1868. The Hancock Congregational Society began its services in today's Masonic building. The current building's stone material was donated in 1890 and hauled by the church building committee for $570. In 1892, the cornerstone of the present building was laid. Always attuned to world events, the church granted its Rev. Christopher Collier a six-month leave, so that he could drive an ambulance in France during World War I. Since this photograph was taken, the church has undergone several building additions.

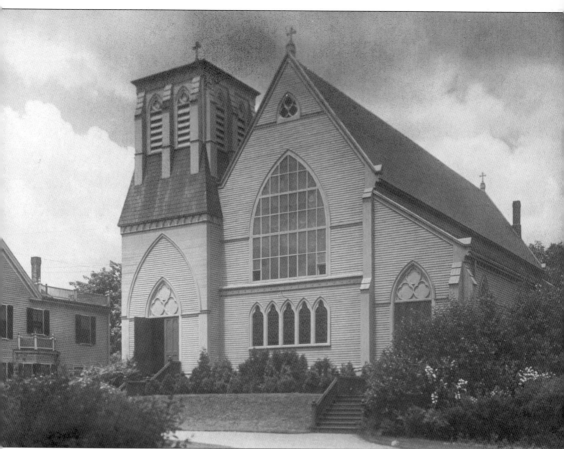

As the Irish immigrant population in Lexington grew, the need for a Catholic church became apparent. The first mass was held in the Lexington Town Hall in 1852 at a cost of $7 rent. After renting the second floor in the Robinson block, Village Hall held mass from 1865 to 1873. Catholics then purchased the Davis estate on the present site of St. Brigid. By 1875, construction had begun for the building, shown here, that became the present building's foundation. Nineteenth-century Lexington's New England Yankee majority harbored prejudices about Catholics common to the era. The issues of temperance and abstinence figured prominently among local reformers. This alienated many immigrants. St. Brigid moderated this animosity by endorsing temperance. Within the church, both temperance and total abstinence organizations existed. St. Brigid continued with religious and social outreach ventures easing acceptance into the larger religious community. For example, it joined other churches for a choral program together. Reflecting its clergy's activist side, Father Casey was arrested in civil rights protests in the 1960s. He also chaired the Greater Boston Fair Housing Federation.

The *Lexington Minuteman* in 1874 reported the first attempt to organize a drum corps, noting that young men had "already commenced their practice, and [they] doubt not will make a favorable report shortly." The first Lexington Drum Corps comprised 11 men under the leadership of drum major Myron Kelley and Frederick Brown. Unfortunately, it declined and disbanded. In 1886, another group decided to organize, but it was not until 1893 that the Lexington Drum Corps cherished by the town for 57 years was formed.

The Young Men's Social Club sport walking sticks as they pose. Its headquarters was over Smith's Paper Store. From left to right are the following: (front row) George Conant, George Russell, Henry Turner, Frank Simonds, Herbert ?, and William Chissell; (back row) William Adair, Harry Chandler, Austin Locke, Charles Adair, Walter Ham, and William Jackson.

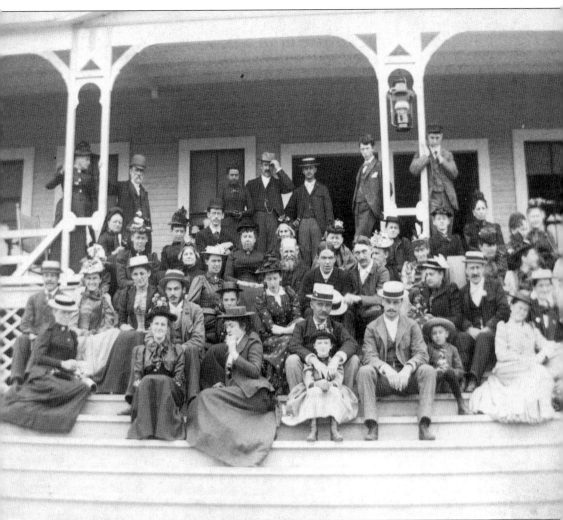

The Field and Garden Club was founded by Lexington residents interested in making public improvements by protecting and planting trees and shrubs around town. Members also studied and discussed arboriculture and horticulture during meetings. Founding members met at various times in the spring of 1876 and appointed A.E. Scott, M.H. Meriam, and J.J. Rayner as an organizing committee. The club's first project involved doing something with the plot of land in front of the Center Railroad Station (later Railroad Park and then Depot Square), which, at the time, was a "veritable slough of despond." Throughout its existence, the club has initiated other projects, such as improving the battle green, Hastings Park, and, for a while, each spring, the club arranged an event in which citizens could purchase trees and shrubs at reasonable prices to encourage larger planting.

In response to a letter from E.G. Porter and C.A. Staples, requesting that a society be established in Lexington for the purpose of research and the preservation of local history, the Lexington Historical Society was organized on March 16, 1886. Initial membership included 84 members. By March 23, 1886, the society had adopted a constitution. Reverends Porter and Staples held office as corresponding secretary and historian, respectively. The society gathered in Cary Memorial Hall for a special meeting on August 11, 1886, to unveil Sandham's painting *The Dawn of Liberty*. Over $3,100 had been raised and contributed to the painting's purchase, which represents the events of April 19, 1775, on the Lexington Green. It still hangs in the Cary Memorial Hall today. At present, the society opens three historic houses to the public— Buckman Tavern, Munroe Tavern, and the Hancock-Clarke House. It also preserves a collection of artifacts and documents relating to Lexington's history dating from the 17th century through the 20th century.

Formerly located on the corner of Muzzey and Forest Streets, the Old Belfry Club was founded in 1892 to provide social and recreational activities for the influential population in Lexington. It boasted a tennis court and a basement with the only bowling alleys in Lexington at the time. The ground floor contained a great hall and reception room, a library, a ladies' reading room, a parlor, and a kitchen. The second floor housed a ballroom that included a stage at one end, in which the club sponsored hundreds of seasonal, informal, and thematic dances. The club members also played a great deal of bridge and whist card games—the Old Belfry Club Whist team belonged to the American Whist Club and the Mystic Valley Whist League during the 1902 season. Despite the club's success, Lexington's population began to change with the building of Route 128 and membership steadily declined (a great fire in 1968 only accelerated its downfall) until 1974, when it was finally dissolved. The building was sold to Grace Chapel Incorporated.

In this 1890 photograph, a group of young tennis players rests on the Goodwins' lawn after a rigorous game of doubles. Among the players are Alice Goodwin, Theodora Robinson, Grace Whiting, May Harrington, Marian Richardson, Curtis Cutler, Frank Todd, Arthur Tucker, and Arthur Stone. The Goodwin estate was located on Meriam Street, marked today by Patriot Drive.

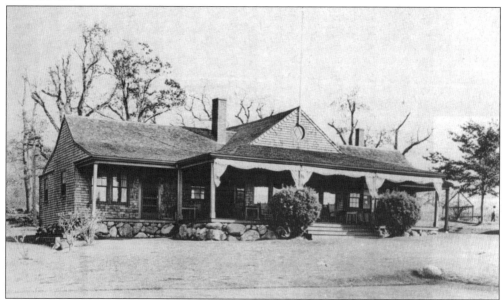

The Lexington Golf Club was founded on April 12, 1895, with John B. Thomas as the first president. The club established a nine-hole course on the southern slope of the hill in the back of Munroe Tavern. An old barn of the tavern was used as a clubhouse. On December 2, 1899, the club voted to lease the Vaille Farm on Hill Street and eventually purchased the land in 1906. The golf course still stands on that location today.

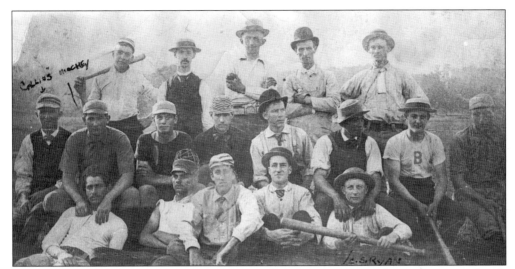

This is the 1885–1886 Lexington town team. Called the Lexingtons, the team competed with Arlington, Belmont, Lincoln, and the Beacon Club in Boston among others, notes Larry Whipple. The team had played together in high school, making them one of the league's strongest. The team's home field until 1885 was the Lexington Green, with home plate on the Harrington Road side. On April 19, 1885, Gov. George D. Robinson, Lexington born, spoke against using the hallowed ground as a ballpark, ending the practice. Among those in the photograph are Billy Ryan and Richard Hinchey.

From c. 1910 to 1940, the Minute-boys represented Lexington in suburban leagues. Games at the Centre Playground drew as many as 2,000 on a summer afternoon in the 1930s. The April 18, 1934 *Lexington Minuteman* reports that the Minute-boys fielded two teams in two different leagues that year—the Metropolitan League and the Paul Revere League. By 1940, the onset of war and organized softball's appeal for the older players spelled the team's demise according to Larry Whipple.

The Lexington Minutemen Bicycle Club, shown here in 1894, met behind the Hunt block at 8 p.m. on the second Friday evening of each month. The club's second lieutenant was George Otis Jackson (front row, extreme left), and its president was Leon Bowers. Its captain was Clifford Currier (front row, third from left), its secretary-treasurer was F.L. Beal, and the first lieutenant was John T. Fiske (front row, fifth from left). One year later, they began one of their "century runs," which involved 100-mile trips around Boston.

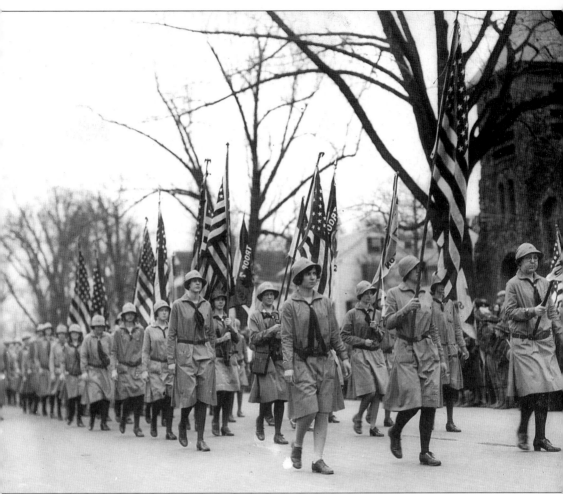

It rained the night before this parade on April 19, 1930, but fortunately for the expectant crowds, the weather "compromised with fog instead of rain." The *Lexington Minuteman* exclaimed that the year's parade was "one of most colorful seen in years." The Lexington Girl Scouts participated with the Boy Scouts as they held the annual flag-raising ceremony on the Lexington Common. At 2 p.m., the Girl Scout groups from Dorchester, Quincy, Bedford, Lincoln, Lynn, Belmont, and Winchester performed a competitive drill on the Lexington Common. Acting as hosts, the local troop did not compete. The trophy, awarded by the town, went to the Dorchester group, with Quincy in second place and Bedford tying Lincoln for third. In the foreground, from left to right, march Ianthe (?) Young, Dorothy Smith, Betty Noyes, Anita Pring (?), Domenica Ciccolo, Ethel Dahlstrom, and Muriel Newcomb.

Community ties cast a wider net in the post–World War II world, as the global community also became important. Here, the Begum (wife) of Pakistani Prime Minister Liaquat Ali Khan accepts yellow roses from Girl Scout Sally Raymond on May 26, 1950. She also accepted the World Pin on the Lexington Green, surrounded by about 600 Lexington Girl Scouts who were excused from school for the day. This pin is a Girl Scout International Friendship symbol. Founder and leader of Pakistan's Girl Guides, the Begum led her husband and 40 dignitaries from both countries to Lexington after she requested to visit an American Girl Scout Council. The event culminated a three-week official U.S. visit sponsored by the United Council of World Affairs. The ceremony was broadcast over WCRB 1330. Behind the microphone is Selectman George W. Emery.

Seven

CELEBRATING THE PAST

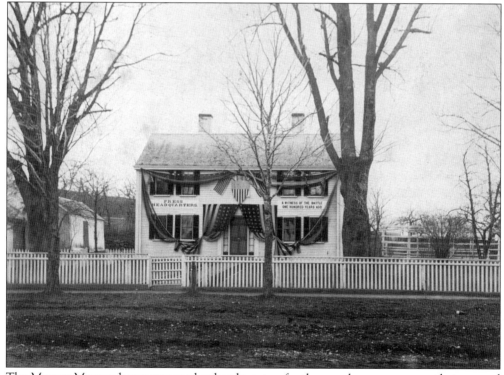

The Marrett Munroe house was used as headquarters for the very large press corps that covered the centennial on April 19, 1875. The lettering on the right boasts that it was home to a member of Parker's company 100 years earlier.

Lexington's centennial celebration took place on a day not rising above 26 degrees fahrenheit. The dignitaries in attendance included President Grant; the secretaries of state, army, navy, interior; and Edward Everett Hale. An estimated 100,000 spectators arrived in Lexington, jamming roads and so delayed rail transportation that a carriage had to be sent to Concord to transport President Grant to Lexington. Charles Hudson enjoyed the honor of unveiling the statues of John Hancock and Sam Adams, created for the occasion. In the pavilion tent on the green, John Greenleaf Whittier read the poem *Lexington—1775*, especially written for the occasion. Some 2,000 braved the dinner and ball later that night. The temperature in the unheated tent chilled the food (shown here) and participants alike. Grant left for William Tower's house to warm up after the speeches and returned only to plant an elm tree at the east end of the common. It died in 1901.

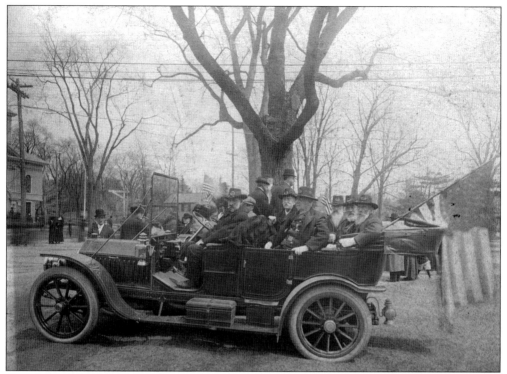

Grand Army of the Republic members gather on what appears to be a Patriot's Day or Fourth of July celebration sometime before 1908. From left to right sit Henry Tyler, unidentified, unidentified, Albert A. Sherman, George Dennett, William B. Foster. The George G. Meade Post 119 was established in 1873 with George H. Cutter as commander.

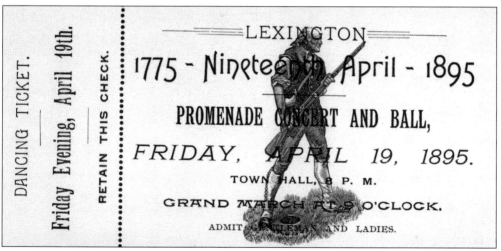

April 19, or Patriot's Day, had been celebrated in Lexington for many years, but, in 1894, due to Lexington Historical Society's initiative, the day became a state holiday. This is a ticket for the annual concert and ball to be held at the Lexington Town Hall the next year. The Lexington Drum Corps provided music for the first time, continuing for the next 57 years.

For the 135th anniversary celebration of the Battle of Lexington in 1910, Dr. Holmes's property was decorated in Colonial colors of buff and blue, with large color portraits of several national figures and used as a hospital called Wayside Rest. The Twin-Elm Spring Water Company, owned by J. Willard Hayden, funded the conversion. Equipped with graduate nurses ministering to the sick, it also served as a retreat for women and children.

Franklin D. Pierce, chairman of the board of selectmen, rides the Patriot's Day parade in 1910 with Pres. William Howard Taft. Pierce also shared a carriage with Gov. Eben Draper.

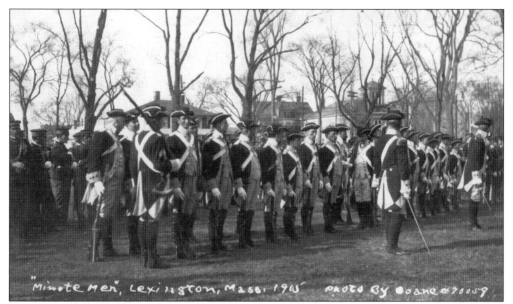

The Lexington Minutemen were reconstituted in 1910, having been disbanded after their one-year appearance in 1875. The organization has remained together to the present day. They are shown here in 1915.

The 1915 pageant was spearheaded by J. Willard Hayden Jr., standing on the right in this 1925 photograph. He provided the initial funding and offered his estate, Twin Elms on Shade and Weston Streets, as its site. Hayden intended the proceeds to build a gymnasium for Lexington's young people. Consequently, the 1915 pageant was to be first in a series. Hayden owned a successful spring water bottling company in Lexington. The 1915 pageant showed a net profit of only $500, hardly seed money.

Cpl. Charles M. Parker, the great grandson of Capt. John Parker, turns the first sod on October 18, 1913, for the Lexington pageant in June 1915. From left to right are George H. Childs, Edward Taylor, Edwin B. Worthen, Alfred Pierce, Mrs. Crosby, Mrs. Leroy S. Brown, Leroy S. Brown, Edgar Parker, Fred S. Piper, Charles S. Parker (editor of the *Lexington Minuteman*), Herbert Locke, and Alonzo E. Locke.

The 1915 pageant's subject was the Dawn of American Liberty. As such, it began with the birth of Lexington. Shown here are nymphs representing nature and the elements. Virginia Tanner, director of dance, choreographed and selected participants in the dance. Tanner had worked earlier on pageants, including one in Brooklyn, New York.

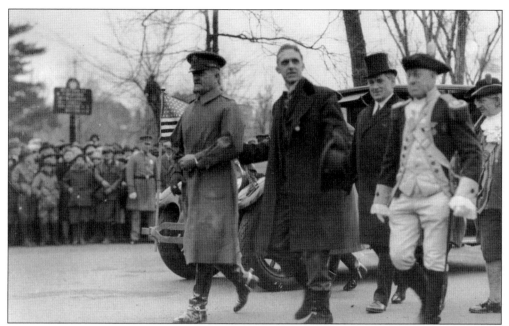

The 150th anniversary of the battle was on April 19, 1925. Participating in this special occasion are, from left to right, General Pershing, Vice President Dawes, and James Michael Curley. In addition, the U.S. Marine Band traveled from Washington for the festivities. As with the centennial, the celebration took place in unseasonably cold weather, with snow having fallen the previous night.

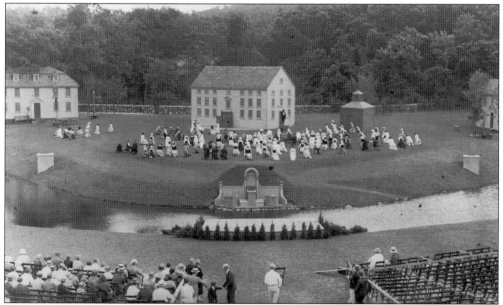

The pageant was scheduled to be held for six evenings, June 15 through June 20, on the site of what is now the high school baseball field. Planning began early. J. Willard Hayden Jr. published an open letter to town in the *Lexington Minuteman* on October 28, 1921, that promoted the event as a "community affair in which every man, woman and child can join." Lexington responded with 41 local organizations and 1,400 citizens participating.

Drummer boys for the 1925 pageant, James Woodberry Smith and Joseph Gibbs Kraetzer reluctantly pose. Total attendance for the pageant exceeded 40,000 with a net profit of $4,150. Hayden intended to organize a 1935 pageant, but, perhaps due to the Great Depression, it never materialized. J. Willlard Hayden's dream of a gymnasium for Lexington, however, was realized in 1958 (albeit posthumously) with the Hayden Recreation Center. When Hayden died in a car accident in 1955, the town discovered that he had bequeathed his entire fortune of $4 million to do what the pageants' proceeds could not.

The 1937 Patriot's Day parade rose to a new level in many ways, according to the *Lexington Minuteman*. For the first time, a locomotive passed on the main streets of town. It was also the first time that such a large number of floats has been included in any parade. The $25 first prize was awarded for the float shown here, created by Briggs Class of the Lexington Baptist Church, a men's study group.